A CRACK-UP AT THE RACE RIOTS

HARMONY
KORINE

A CRACK-UP
AT THE
RACE RIOTS

DRAG CITY | CHICAGO

DC486

Drag City Web Address: www.dragcity.com

Printed in the United States of America
Library of Congress Control Number: 2012953314
ISBN: 978-1-937112-10-3
Cover artwork by Harmony Korine

First Drag City Edition

CONTENTS

**A NOVEL SETTING ABOUT
THE BASTARD WISHER:**

PART 1
CRACK-UP AT THE RACE RIOTS
1

PART 2
SWAN SON OF THE SPICK
93

PART 3
LIKE A TURK IN STOCKHOLM
133

A CRACK-UP AT THE RACE RIOTS

CRACK-UP AT THE RACE RIOTS

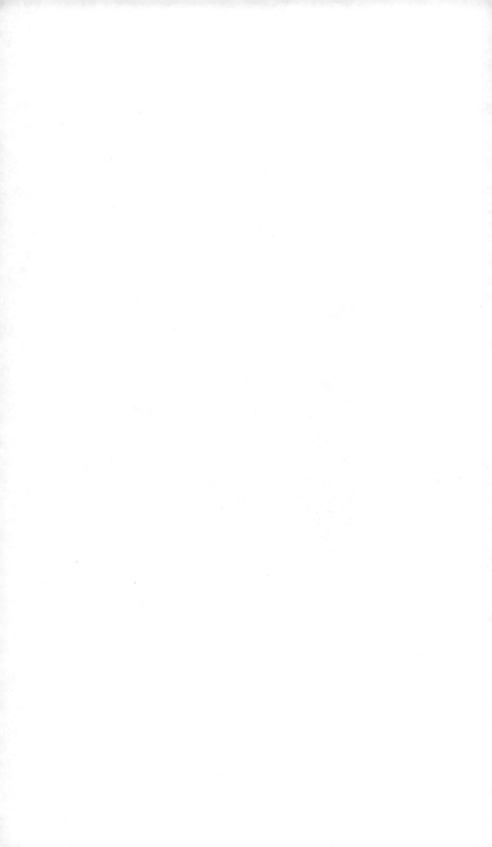

mc hammer age 11

TITLES OF BOOKS I WILL WRITE

1. A Life Without Pigment.

2. Foster Homes and Gardens.

3. Change Is Good.

4. Tell the Egyptians That I Will Flee.

5. Gentle Jesus and Drugs.

6. Living Proof: My Diary 2.

7. Can't Touch This.

8. Oh Mr. Porpoise.

9. They Hung Their Heads in Shame.

10. Soon He Had the Box Uncovered.

11. Chink-en I'll Pluck Your Slant.

12. Shit for Brains.

PART 2

13. Calvin Klein Is a Flamer.

14. God Now Had Grown Bolder.

15. The Abuse of the Groin.

16. Italian Honkies.

17. Vacation.

18. Holy Roller Swollen Hand.

19. Peabody Award. Shithead Trophy.

20. Gimme Some Clit.

21. Diary of Anne Frank Part 2.

22. Petty Rural Crime.

23. Help Me Rhonda Yeah Gimme Some Head.

24. The Burmese Girl Waits to Get Serviced.

25. The Truth About Winn-Dixie.

"He had disgraced himself in the orchard for the final time. He took out his section of the tree and folded it under. Then, to make matters worse, he craned his neck forward and began his trademark search, a collection of answers that he applied to everything. This was his peculiar trick: he could turn himself inward like his pet crane. He had learned how to dance in an informal way, his masters leaping, he could spin on toe, he could stand on stage smoking a pipe and faking his father's death, then get the crowd behind him, clapping behind him, and in front he could be pleased. But today's disgrace was final, he had no desire to even question his picks and pans, because the tree fit perfectly under his arm in a way that the fruit fell upwards, and the answers fell upwards."

— T. S. Eliot

T. S. Eliot's last words

"I'm so unlucky, the mirror I broke was a black cat."

(Bob Hope and Bing Crosby are riding a camel across the desert. Bob Hope is wearing a red Mason's cap and pointed slippers. The two of them are very thirsty, they have just sung two lengthy songs in a row. Bing Crosby looks up at the sun and sighs.)

BING CROSBY: Look at all this sand.

BOB HOPE: This must be the place where they empty all the old hourglasses.

2. Mario Lanza almost drowned when he was a boy.

3. Ron Howard is the exemplary child given over to the society of Jesus called Hollywood.

I was talking to this British lad who told me he had an epileptic seizure in the middle of *Old Yeller*.

THIS SCENE TAKES PLACE
IN A PUBLIC SWIMMING POOL

DEBRA: Her ex-boyfriend would stand in front of her window waving a gun. She had very long extensions and just terrible fashion sense. She was the type of girl you don't mind so much when you hear that her boyfriend beats up on her.

ALAN: What about the kids?

DEBRA: Well, her children are innocent and all. I have to admit I get angry when I hear about the kids.

i bet you have no more friends
than an alarm clock

THE INCREDIBLE CASE OF MEDICAL MONA

At ten o'clock that morning, Mona got an abortion and now, later that same day, she was in the kitchen making me a hard-boiled egg. She had woken up holding a hamburger in one hand and the liner notes to an M.C. Hammer tape in the other. While I was eating the hard- boiled egg, the smell kept making me sick because I was visualizing Mona's legs spread and her getting an abortion. She said she was going to go shopping for panties this coming weekend. She read me the letter that her East German pen pal had just sent her.

Dear Mona,
This is true, I got an ear infection in both ears and this prevented me from doing my job this week so now I have lost a week's money but I'm still all right. My brother is getting a divorce but I have seen it before so till then I will just wait and see. Can you send me a picture of your Corvette car so I can show my boyfriend? He has trouble believing me, like all men. I used to be obsessed with a clean car, you know the inside had to sparkle. It's funny but the time I was taking real good care of my car I was thinking about becoming a doctor.

JOSEPH MOHR: I was doing all right until my youngest daughter married a spick.

LEONA UPTON: You shouldn't complain. At least your daughter married. Mine hasn't so much as gone out on a date since high school.

JOSEPH MOHR: My daughter had a spick baby and that's not the worst of it.

LEONA UPTON: Why, what is it?

JOSEPH MOHR: She called me up on the phone yesterday and told me she was going to adopt a baby with a bad kidney that she had read about in the paper, and I said, Are you crazy, first you have to go off and marry a drunkard spick who can't even afford to buy you a turkey for Thanksgiving and now you're telling me you're going to adopt some sick child.

MOVIES

1. A newspaper reporter realizes that his wife has been lying about her age. This makes him wonder what else she has been lying about.

2. A group of adolescent city kids help a crippled veteran buy a chicken ranch.

3. A schoolgirl with a ranch of horses falls in love with an aging pediatrician.

4. A former prostitute with a low IQ poisons her priest.

5. An alcoholic tap dancer is rehabilitated.

6. A gangster flees to Alaska in search of gold.

7. A grumpy nanny goes fishing one day and discovers a dead body at the bottom of the lake.

8. A prostitute decides to run for mayor.

9.

10. A schoolteacher takes her class to Israel where they spend time on a kibbutz picking dates and planting corn.

11. A former drug dealer decides that he wants to become a professional basketball player.

12. A paralyzed mentalist turned ivory trader takes revenge on his cheating wife.

13. A young rabbinical student decides to help save the rain forest.

14. A troubled playboy decides to overthrow the government.

15. Two children find a dead body in the woods.

16. A gay man gets hit by a car and no one cares.

17. A famous fashion designer has a nervous breakdown after the president is assassinated.

18. A has-been opera singer is stalked by a Chinese immigrant.

19. A former Nazi seeks refuge in a small Mexican town.

20. A dentist finds a hundred thousand dollars in the crevice of a cello.

21. An aging actor decides to rape his teenage daughter.

22.

23. A communist nurse decides to write a play.

THE TWO JAMES MADISONS

There are several things that you should know, the hows and
the whys that I ran for public office; what was my reasoning
and where I wanted to go with it. As a child my older brother
took me to see the film *King Kong*. In the audience, after
the event, I spotted a tall slight man with a short horseshoe
beard and a tan overcoat. I thought him to be very dapper
in his dress. He seemed quite at peace with himself, in the
middle and calm. I asked my brother the name of the man.
My brother, a keen gimp, knew immediately. He told me
that it was James Madison, no relation to the politician, he
added. He was, in fact, a newspaper writer who was known
to have had a profound impact on architectural criticism, a
truly stellar figure in the world of urban design. It was the
connection between the names that I was taken by, he and
the famous politician were in fact physical opposites. It was
these two men who I modeled myself after. I remember from
my observations that one afternoon in the theater his slight,
delicate movements, the falling wrist and the straight neck,
the self-assured attitude, the almost imperceptible air of
superiority that enveloped him so that he seemed impervi-
ous to the tawdry goings-on of everyday life. It was this one
afternoon in the theater that so struck me that years later it
was this James Madison of my memory who I imitated. Then
I took on the personage of another, the politician, his stern
face in the passages of books. A mediocre man with a jutting
jaw and a little shapeless forehead. It was in this manner that
I made my way in the world, that I was introduced and that I
could clear my throat and have men listen and take heed of
my opinions and observations. The women were no different
really, except they would more or less swoon and bop, their
eyes hoping that perhaps I might engage them in some idle
chatter. It was in this order that I adopted the mannerisms
and countenances of the two James Madisons. My brother's
laughter fills the room when we have this discussion. He says,

"You know it could have gone the other way, you could have taken on King Kong."

PASS HIS ASS (I MEAN THE SALTSHAKER)

FAG BASHER 1: Linda's brother Eric is a faggot.

FAG BASHER 2: No way man, I went to school with Eric.

FAG BASHER 1: I saw him walking into a gay disco with a bunch of other homos and they were all wearing acid-washed jeans. Eric had on these tight jeans and a fucked-up feathered hairdo.

FAG BASHER 2: Damn man, I can't believe it.

FAG BASHER 1: Do you remember that time we were driving with him and he got pulled over, the cop comes over and Eric goes, "Hey, hey, I didn't mean to run that there stop sign, Officer."

FAG BASHER 2: Yeah.

FAG BASHER 1: That's when I knew he was, 'cause his voice just sounded straight-up faggot, I knew it then. He sounded like a ten-year-old girl.

*(Fag Basher 2 yawns and picks up an issue
of* National Geographic.*)*

FAG BASHER 2: I would love to go to Australia.

FAG BASHER 1: Oh hey man, I taped *Crocodile Dundee* off the TV.

FAG BASHER 2: My wife loves that movie.

AL JOLSON: I went to a strip joint and saw a lady who was eight months pregnant taking her clothes off on stage. She was wearing a surgical mask. When I asked her why, she looked at me and said that it was an unhealthy environment.

SPEECH OF A RECKLESS HO

Sometimes I actually steal ashtrays from the hotels in which I commit adultery.

TO HELL WITH ALICE
AND HER CORPORAL PUNISHMENTS

Kris Kristofferson was trying to teach Tommy to play the guitar. But Tommy told Kris that his twelve-year-old fingers were too small to straddle the guitar. A fight between Tommy and Kris ensued whereupon Kris spanked the smart-alecky Tommy on his bottom. After this Tommy's mother got angry and left Kris's house. In the car on the way home, Tommy was acting snotty to his already upset mother. In order to prove a point she made Tommy get out and walk home. Tommy went to his girlfriend's house and got drunk on Ripple. His mother, not knowing where he went, cried at the thought of her son being kidnapped. In her mind, as she was driving, she thought to herself, No discipline is worth my son disappearing. While she was torturing herself, Tommy was getting drunk for the first time in his life and having a wonderful experience.

TOMMY: Sorry Mom, I stole a set of guitar strings the other day while my girlfriend faked a seizure.

Jeremy Dawson was a young filmmaker from Cleveland. It had been three weeks since he had seen his girlfriend. The two of them were so happy to see one another that they began dancing cheek to cheek in the kitchen.

I. She told him that it was important for them to dance at least once a day.

II. They were listin to "you gotta move" by the rolling stones.

III. He thought to himself, this scene would probably cost around "l00,000" to replicate on film.

Later that evening
Jeremy dawson – where do you want to eat?

girlfriend – some where with good shell fish.

A MARYLAND GOSSIP

(He went to this clinic inside of a strip mall and got a colonic enema and the doctor there said he found a green plastic toy army figure that had probably been stuck in his bowels for over thirty-five years.)

TEEN BOY: I found a stolen sink at a garage sale.

TEN ETHNIC ADOLESCENT ATROCITIES: PICTURES

1. Two cute round-faced teenage Hasidic boys with long blond curls falling down the sides of their faces are standing next to one another playing banjos. They are standing in a snow-covered field that is almost completely white except for a few small trees and a wire fence far off in the distance. In front of the boys is a halfway-dying deer with an arrow sticking straight through its neck and a small pool of blood collecting beneath it in the snow. The deer is beautiful and cream colored; it is looking up painfully at the sky and it seems to be in a considerable amount of pain and agony. Despite the cold and the snow neither brother is wearing a shirt, only long black pants. The two boys look like identical twins except that one of the boys is a bit more pudgy than the other. Their skin is very white and sickly. You can see their footprints in the snow. Both boys have long dirty fingernails and pointed teeth.

2. A basketball coach is yelling at a slouching teenage boy. The boy is looking at something else. He is wearing a tight short-sleeved polo shirt and a crucifix necklace. The coach is wearing a white jersey with the name of the school printed on the breast pocket. The coach has a pin-sized head. They are both sitting on wooden bleachers. The boy is sucking his bottom lip.

3. A four-year-old girl is standing in front of a burning barn. She is holding a dead chicken by its neck. The girl is wearing an oversize diaper.

4. A bunch of teenage black girls are beating up an overweight white girl. Her shirt is torn and one of her breasts is scraping on the pavement. They are in a crowded parking lot. A few people are standing on their cars watching. All the black girls are wearing Elton John T-shirts.

5. A pretty blond nun with golden hair has her skirt pulled up and is squatting down urinating on a haystack. Behind her is a spotted horse with a saddle. The horse is watching the nun.

6. A fifteen-year-old boy who is completely naked except for a ripped T-shirt and a pair of flip-flops is standing in a kitchen. He has red curly hair and just a very small patch of pubic hair above his penis area. He has one leg propped on the kitchen table. A woman old enough to be his mother is sticking her ring finger up his asshole. The woman is wearing a crappy green flannel nightgown. Her legs are up and you can see her panties. She has a very serious look on her face like she is hoping to find something. The boy is holding a toothbrush in one hand.

7. Three short Chinese men in business suits are wading in a pond. They are all three laughing and smiling. Their pants are rolled up to their knees. The man in the middle is holding a protest sign that reads, "Abortion is murder."

8. A teenage boy and a teenage girl are dead and hanging by their necks with ropes from a branch of a huge tree. They are both naked. The boy's left foot has been cut off. A small dog is sleeping next to the tree. The symbol for Prince has been carved into their bellies. The girl has small fingers and boobs.

9. A ten-year-old black boy with a large white neck brace is standing in front of a long mirror in his bedroom. He is wearing tight white underwear. He looks very sad. In the background are three small children sleeping in a bed. On the wall is a rebel flag. Clothes are scattered all over the floor and a pile of books is stacked up next to the bed. A small chandelier hangs from the ceiling.

10. A sixteen-year-old boy who looks like Matt Dillon from *Over the Edge* is sitting on a silver BMX bike in front of a gas station. The boy is wearing tight blue jeans that are way too

short. He has a small cross earring in one of his ears and one of his elbows is scabbed up and bruised. He has no socks on and his tennis sneakers have no laces in them. He's wearing a tight Slayer T-shirt. His teeth are all crooked. There are thin lines shaved into his eyebrows. A sexy fifteen-year-old girl with bleached-blond hair is sitting a few feet behind the boy. She is sitting on the dirty curb in front of the store. She is holding a can of beer in one hand. She is wearing a light yellow tank top and tight red shorts. Her face is narrow and pretty. She is barefoot and her toes and legs are dirty. Her ears are pierced several times on both sides.

HE USED THE ROOT FOR A PADDLE

ME: Would you if he asked?

MASSEUSE: Would I what?

ME: If a guy with AIDS asked you to rub him down?

MASSEUSE: Of course I would. Why wouldn't I?

ME: What if he had lesions?

MASSEUSE: It depends.

ME: What if he had an open sore and he pleaded with you to stick your finger in and massage it?

MASSEUSE: Obviously I'd say no.

ME: If he begged you and he even said that you could wear thick rubber surgical gloves.

MASSEUSE: I have my limits.

BOOKS FOUND IN MONTY CLIFT'S BASEMENT

1. Galswothy's *The Forsyte Saga*.

2. D. H. Lawrence's *Lady Chatterley's Lover*.

3. *Tom Jones* (There were two small notes scribbled on page 14: "A little coitus never hoitus"; "Let's not lose Mars to the commies").

4. Ian Fleming's James Bond.

5. Proust.

> Tupac Shakur.
>
> Caput Rukahs.
>
> Kaput Raucous.

1. Eddie Money is broke.

2. Johnny Cash is poor.

INFORM THE STAGECOACH
A BLEEDER IS ON THE WAY

As she crept near the woodpile, a dirty whore-bag in green shorts and no brassiere, I clamored with my wife to catch a glimpse of the poor girl from the window in my door. I dropped the slice of cheese that I had been cutting for the past few minutes. See, years before I had collapsed on this woman's porch when I was struck by a truck, I kept being surprised at how wide the muscles on her arms were. "Tell me what to do or should I just call the police, oh I don't know, I don't know what to do in this sort of situation," she had said. She'd taken me into her bedroom and had tried to seduce me when the sores healed.

The jargon that the ho-bag was screaming today in my bushes seemed almost indiscernible, like a bloody mouthed beating victim, and it reminded me of all those hundreds of mood swings that my wife falls prey to. "Look, she needs a helpin' hand," I told my rust-colored wife of some fourteen years. But my wife, holding on to some deflated memory, tried to stop me. She would just as soon let the bitch die dry in the woods next to the woodshed that was owned by our now deceased bastard neighbors. "Well if I don't help her out I should at least inform the paramedics," I told her, and this my wife conceded. Later that night, I found out the truth: that her husband had been abandoned by the army and had beaten her and then stolen the Volvo.

1. My dad used to try and pull my mother's nipple off her titty. He would try and bust her pelvis off. He never felt strange about popping her in the face in front of friends or grabbing her titties in the grocery store.

2. My mother used to abuse my father. She would light his hair on fire and stick pine needles up his urethra hole while he was sleeping. She used to spit in his pancakes and swat him in the face with a hairbrush.

3. My father believed that rape should be legalized.

MY grandfather used to Paint himself Black and do tap dances , on broken mattresses

MY grandfather was a comedian who used to paint his Face black. i never thought he was funny, people were happy when he had a stroke

my grandfather was jelous of black people. he used to paint himself like a negro and stare in mirrors

When we heard that John Candy had died, for some reason the first thing I thought was that it was probably some sort of drug overdose. But then Bobby slapped me on the back of the neck and reminded me of how overweight he had really been.

1. "Damn you for always thinking the worst of people"

Q.tristam Shandy
a.ray Liota

Q - i made out with Jessica tandy before she passed away

Q: A person can characterize himself as a democrat, a tyrant, a Christian, a resistor, an anarchist, a liberal, a conservative. How do you describe yourself?

A: I'm a romantic anarchist.

LAWRENCE STERN: I keep dreaming I can't sleep. It wears me out. Last night I dreamed that before I went home I had to paint the whole building. I thought: that'll take time.

cinema- Kevin Costner

c. Seeing or Believing

1. Butch Cassidey
2. Hector Babenco

there is no film without love
love of some kind. There can
be novels without love, other
works of art without love,
But there can be no cinema
without love.

A. For a short while I knew my mother was passing away. My boss at work told me to spend as much time with her as possible. He gave me a week off from work. On the second day of my leave my mother died in her sleep. When I came back to work, my boss told me that he had just given me a pay raise and a larger, more luxurious office directly across from his.

B. A legend—Arnold Palmer.

THE CORKED ARISTOCRAT

"The glory of God is mankind. After I raped and killed my only love by shoving a champagne bottle completely inside her uterus and destroying her pink-faced angelic grace, I sat down on the floor of the hotel room and wept because all I ever wanted to do was give the world a little joy, make them giggle. But somehow God allowed the champagne to take control of me. I am fat, I'll die soon, as a boy my mother would give me sugar bread after every time I rubbed her brittle feet after work. I massaged her so well that the sugar bread made me who I am today. I just wanted to make the public love me, but eventually I was alone with my murdering bottle. I will be gone soon, so tell a joke and dedicate it to fatty The sugar-bread showman. And when I leave this place I will sing an opera with Valentino that will bring the heavens to tears, and you will all be soaked in Fatty's redemption. I wanted to be an aristocrat. I just wanted to make the people love me. I love them. I'd love a bottle of wine just now."

(Fatty Arbuckle's note, left on his broken antique armoire)

SCENARIO IN FOUR-PART HARMFUL

An arm wrestle with Dad led to the demise of his self-esteem.
Wagner in tights = gays on parade

BASTARD WISHER: I was on the back side of the taker's prank.
I had never pretended to play those angles. If the Lord had
sent a sucker out it was only his duty to play the part. I was
charged double the amount on the head of three pints. I
anted up grinning in the swatch of truth. No fool was I,
it was the taker's mistake. Had he thought me that silly? I
waited at his door at 2 a.m. and still drunk. The taker fell
on his knobs. I haven't seen a decent pair of knobs since I
raped the widow in front of her grandchildren.

LETTER FROM A SAILOR: CIRCA 1928

Dear Mother,

Thank you for sending me the book on Catherine the Great. I've only read the first three chapters, but hopefully I will have it finished soon. I did something I thought I would never do: I tried fish for the first time this evening. It was the only item on the menu so I convinced myself, what the heck, and it wasn't all that bad. Buster, one of the boys from Mississippi whom I bunk with (actually my only true friend here), pointed out the irony of waiting to eat fish on land, as opposed to on sea. When I'm on the boat I usually eat only greens and rice, but surprisingly I've managed to maintain my weight. Being in this city has been quite a big bag of adventure. Yesterday I saw a man on the street hammer a nail straight through his neck. I swear it went in one side and out the other. He asked me for some money and I gave him some. I want to come home and go horseback riding.

<div align="right">

Love, Your Son,
Murry T

</div>

i dream of killing mother.
i ~~will~~ will saw off her
~~head~~ head. her lessons are
her only possessions. this i
was taught.

if i had to describe myself i would say
that i ~~was~~ am a cross between # Jack Parr
and Micheal J. Fox.

annie LeNNox's first Job was as a fish filleter.
at least it gave her plenty of opportunity
to practice her scales.

my best friend Jordan used to put up
stickers in phone boxes for prostitutes, as well
as being a bike courier. He married my first
love from high school but she died of cancer
a little bit after they had thier first
child, a short ~~child~~ bratt with knotted hair.

an unbreakable toy is one a kid uses to break
those ~~that~~ arent

dana delany	Leon Redbony
willam datoe	Tom Petty
Sue williams	Sear Sucker

Heavey metel kids love satan man 666
in the palm op thier hand

LITTLE IN ONE REGARD

1. A great break of trust that precipitates the erosion of a great relationship.

2. Buster Keaton once told a story about a friend of his who went to a store and bought a piece of a real meteorite. A few months later, the man got into an argument with his girlfriend and he threw the meteorite at her head.

3. He goes home and dances with his father, then they eat a watermelon.

4. He tries again in vain to kill then swan.

5. Freebasing cocaine on a windowsill, I thought I recognized H. G. Wells.

THE MOST FAMOUS HOME MOVIE

1. Peter Sellers playing in a field with a spotted cow.

A MARTYR'S CROWN: ERASMUS'S GRANDSON

Raised on a small farm in rural Bavaria, he had never seen
a movie until his eighteenth birthday. His stepmother was
a kindhearted whore who dreamed of becoming a top chef.
Shortly after the boy entered puberty he began playing
the piano for his stepmother's patrons. On one occasion a
crippled man gave him a gold stopwatch.

CRIPPLED MAN: There are hundreds of longer sentences that
read the same both ways. Here are a few clever ones.

Straw? No too stupid a fad. I put soot on warts.

A man, a plan, a canal—Panama!

Was it a bar or a bat I saw?

Draw pupil's lip upward.

Ten animals I slam in a net.

Poor Dan is in a droop.

CONTINUED:

~~love~~ ~~this~~ ~~what~~ ~~i~~ ~~was~~ ~~doing~~

When i was younger i babysat for a german family who lived a few feet from a pond. It was spring time and i was giving one of the younger children a bath. The oldest child who was around five years old ran into the bathroom Screaming her head off. ~~she had tears in her eyes.~~ ~~she what had happened was~~ She told me that a horse had fallen into the water. when i went outside i saw a dead dear floating sideways in the pond. That night the girl admitted to me that she and a friend had set up the trip wire that caused the animal to die. it was difficult to ~~yell at the girl~~ reprimand the girl because she was still too young to differentiate between a deer and a horse.

31.

This fat kid with Down syndrome came running through my front yard with a stolen bike. He was wearing two different kinds of shoes and although he looked young he was almost completely bald. He got on the bike and rode it directly into a tree. I watched him do this over and over again. After about half an hour he was completely bloody and cut up. When my father came home from work he called the police, and nearly an hour later they showed up with the kid's parents and the people whose bike he had stolen. His father walked up to the boy and grabbed him real hard by the back of the neck. The boy started screaming nonsense out at his father. His mother slapped him on the cheek. She walked up to one of the police officers and said, "To hell with all the retarded children. They're just more trouble than you could imagine. It's just not worth it." The police officer said, "It's OK miss, we're not gonna press any charges on the boy."

GET ON A BOAT, LET'S SEE IF SHIT CAN FLOAT

When I was in grade school, I had a slight crush on the president's daughter. I had first seen a still photograph of her on a national news show. She wasn't the president's daughter yet because he hadn't been officially elected. There was a quick two-second sound bite of him saying, "I like the Christian life," then her picture flashed and she was smiling with a large set of braces stretched across her teeth. I remember the first time I started getting into child pornography, I had ordered a Danish novella called *Swallowing Rusts Braces*. In the book there was a picture of a girl who looked similar to the president's daughter. I called a friend of mine who was involved in Washington politics and asked him to send me as much information on her as he could find. I started keeping a small file of pictures. I've labeled the file "The Age of Politics."

GOLF: When the president plays golf his daughter always stands on the green and watches, wearing a short skirt that comes up above her knees.

FISHING ENTHUSIAST: In case a nigger messes with me I keep Mace in my side pocket.

Kenny was watching WWF with his father on the couch in the living room. His father stood up to get a bowl of popcorn from the kitchen. Kenny had gotten an erection. He walked into the bathroom and locked the door behind him. He took one of his father's girlie magazines out from underneath the sink and began flipping through its pages. His erection immediately went soft. He put the magazine back where he found it and walked back to the living room where his father was watching WWF. After a few seconds of looking at the television Kenny began to once again grow erect. He took a pillow from the side of the couch and put it on his lap. At that moment Kenny realized that not only was he gay, he was also only attracted to wrestlers.

KENNY: Are there any lifeguard positions hiring?

SWIM COACH: No.

Roscoe Arbuckle
I gave up bowling for sex—the balls are lighter and I don't
have to wear shoes.

Marion Davies

Al Jolson
We are all basically bisexual.

Betty Jewel
I had to kill my husband because he was making a mockery of
our marriage.

Sally Rand
Once when I was a little girl I saw a man walking down the
street with his pants pushed down to his ankles. He was hold-
ing a bow and arrow.

Fred Astair
Incest is relative.

Bert Lahr
My first job was as a butcher's assistant. My second job was
working at a kennel with my husband.

Lupe Vélez
May poisonous snakes dwell in the corners of your cupboards.

Frank Jenks
If I saw a small bird bopping up and down on a tree, the first
thing I would think of would be, I should kill it, I should
shoot it.

My brother had a heart attack snorting cocaine off the cover of a Pete Seeger album.

Q: Why do you look so haggard?

A: Fuck, I remember doing angel dust with this girl who was a nurse. She used to buy us children beers and rent horror films. It seemed to me she always had a cast on her arm.

Q: I haven't spoken to Clifford since the wake of his uncle. Have you spoken to him in a while?

A: He was talking about his kids, how many he had. He said he had nine kids. He said I gotta trade her in. He was talking about his wife.

Q: Henry ate the last fish? But how full is the tank? Is it still full?

A: Yeah, don't worry, there are fish galore. In fact, it looks like a rainbow: red, blue, yellow. Those colors are festive.

Q: In church the other day, I saw you crying by the water fountain.

A: I remember the doctors were talking about whether to cut above or below the knee, and how I would never be able to walk regular, and about two feet from where the doctors were sitting, there was an open window, and I remember just thinking that I should just run over and jump out the window and just end it all...you know, just like that...and then I asked God if he would please let me keep my leg, that from then on I would walk for him, I would stop walking away from him and start running with him, my legs as his vessel.

She was a sweet girl and her skin was like butter cakes. She died in a swimming pool. Her mom looks like a goat. I don't see them much. Not much since I got her head caught in a car window. Did Lacy die? Did her dad say "nigger" in the car? I don't know.

She's got a ticket to Night Righter
with Winona writer
easy whiter

She's got a ticket to Night Righter
with Winona writer

easy | whiter

flower

Clower

i mean jerry Clower

country Performer

PUSSY IS ALWAYS IN MY HEAD.

head aches and aspirin girls

[4 girls I have a crush on] time of the month

1. mom

2. ⟨scribbled out⟩

3. jessica tandy

4. a girl who's father invented cough medicine

is it religious? oh yes reply

i went to the sony imax theatre and
sat next to Doogey Howser. He said that
he had seen "the Last Buffalo" over 20
times

there were four cool girls in my high school
and they all loved to listen to thrash
metal. One of the girls joined the navy
even though she had flat feet.

bands

venom
metallica
anthrax
megadeth
slayer

I was walking home from the theatre with Goethe
this evening when we saw a small boy in a plum
~~colored~~ colored waistcoat. youth, Goethe said, is the
silky apple butter on the .good brown bread of
possibility

Jackson Pollock Had a foot fetish

1

Jimmie dawson was
a young filmmaker
from Holland

parachute Battalion
3. THree boys go through parachute training schoo

Night monster

1. murders are committed in a srooky
house by a cripple who produces
synthetic Legs by Self hy-otism

2. night has a thousand eyes

a vaudeville mentalist finds that
he really does have the power to
predict the future.

Dirk Bogarde was molested in a movie theater when he was a boy. The man was wearing a beige overcoat and had beige freckles.

Sophia Loren spent seven days in prison for tax evasion.

1. winston churchill
2. wild man fischer

1. For the most part, his work habits were up to snuff but after the thief took off with the goods we saw no point in keeping him around. There is a fine line between trust and marriage but in the mountains where I grew up, next to the public school where no one went, we found out the truth.

2. Chuck Berry: at the height of his fame as a rock-and-roll singer, Berry was convicted of transporting a fourteen-year-old girl across state lines for immoral purposes.

3. James Brown used to steal clothes out of parked cars.

everyone i went to jail with has since passed away.
1. i stole over 300 terry cloth bathrobes in my hay day.

A. THE DRUMMER IN THE CHURCH BAND WAS YOUNG AND NEGRO

Skinhead Boy Movie

1. Standing in his room doing a Nazi salute.

2. Father comes in and tells him to shave his crippled sister's legs.

3. He shaves her legs.

B. JACK WARDEN—WHAT HAVE YOU SEEN?

BRUTUS: What have I seen? I've seen a man get killed. I've seen a man get shot in the stomach and die.

JACK WARDEN: What did you do?

BRUTUS: I started dancing around, because there was music coming from out of the store behind from where the dead man got shot.

TRICKS

*(I met a young magician who only liked to talk about Harry
Houdini. He was a virgin when I first met him. A few months
later he had sex for the first time and I never heard him mention
Houdini's name again. We spent our vacation together
in Florida going to several car auctions. While test-driving
a small vintage race car, I asked him why he never
spoke of Houdini anymore.)*

MAGICIAN: It's true, I've all but forgotten Houdini. In fact
tonight I'm going to try anal intercourse for the first time.

ME: What does that have to do with anything?

MAGICIAN: Pussy takes precedence over all.

(Then he pulled a rabbit out of my ear.)

FORMULA FOR THE SALON

Fred kept on insisting that we take a trip to Hawaii. I had just given birth to our first child and I had huge stretch marks across my belly. It wasn't that I didn't want to spend time with Fred alone, it was just that since high school I have felt extremely self-conscious about my body, and after giving birth, and experiencing difficult changes, I just felt nervous about walking on the beach in front of people. Fred, who had just broken his elbow playing touch football with his younger brother, felt that relaxing in the cool Hawaii sun would help it to heal. I told him to go without me, but he said, "This should be our time together, we never get a second just to be alone, you know." I told him that I would go only if he bought me a really nice one-piece bathing suit, or a baggy sundress, at least then I would feel more at ease. He was so pleased that he went out to the shopping mall and bought me four beautiful bathing suits from my favorite surf shop.

Redd Foxx did not like gay people.

Three months after my father bought me the yellow prom dress, he died in a helicopter crash. Right before he died he told me, "The only place a girl should be on a motorcycle is right behind the man with her arms around his waist." A few days after his funeral I fixed up one of his old bikes and rode it to an Indian reservation.

CHIRP

He claims to have sat on an egg for four days and hatched a
small song bird. But after raising the bird from its infancy all
the way to its early adolescence, curing it of throat cancer and
watching its fur grow healthy, he threw a party for the bird
and invited all his friends over for coffee and cake. He took
the bird out of its cage to show it off. But in all the hurry and
excitement the bird flew from the shoulder of a guest straight
up to the ceiling fan and the blade from the fan sliced the
song bird's neck clean off and the bulk of the bird's sternum
plummeted back down straight onto the same guest's shoul-
der. The guest began to weep out of a sense of guilt. The man
who raised the song bird locked himself in the bathroom, got
down on his knees, and vowed to God he was never going to
have children.

STORY OF A SURVIVOR

The old man was standing up above the toilet. He was crying because there was a bunch of shit and blood on the sides of his legs. He had already had three hemorrhoid operations and more than a dozen pelvic exams.

Before the Man Turned Old He Vaguely Resembled Four Other People

1. Ages 9–11: Gary Cooper from his early years in the Chaplin films.

2. Ages 14–17: Emilio Estevez.

3. Ages 38–41: Mikhail Baryshnikov in the film *White Nights*.

4. Ages 53–54: Judd Hirsch in the film *Running on Empty*.

> Q: What did the punk rocker say to Milton Berle when he wore a plain black tuxedo to the Friars' Club ceremony?
>
> A: At least you don't resemble the hippies.

"a lot of good it'll doher," he said. "I got every shamus in Paramus on my payroll But we wasted enough time here — there's more important stuff to do. Drive me to the Fulton Fish market."

Q are you irish
A-nah im white
A-i can see the arab in him

Harry

55

i used to live next to two old lesbians. they kept a middle aged border who was a camp counsler at some sailing camp on the chesapeake bay. Once i walked by his window and heard a song by a band called Queen. when i looked in his window i saw him totally naked lying on a bed with his legs spread. He had a cigar in his mouth and he was chewing on the tip of it. i stood there and watched the guy for a while, until one of the old lesbians yelled out ~~window~~ at me "Quit spyin on the house guests, thats an invasion of privacy." i said "but hey the guys naked." and she said "so what, we're all born naked."

Herm

DADDY'S A BLEEDER

My heart belongs to all the great tap dancers of the past and to all those people who could've been great if it weren't for the Holocaust. I truly mean that. Their lingering virtue allows me to continue.

Q: How do you get by in winter?

A: I stay close to the heater. At night I snuggle up close to my wife.

Q: How long have you been married?

A: It will be twelve years, come this spring.

Q: How did you first meet?

A: Well, let me see. I think we first met on the set of *Little House on the Prairie*. I had just started working there as a production assistant and Mary was an extra. She had to wear a wig and at first I didn't notice her at all because her hair was in her face, but when we finished shooting I saw her with her real hair, which was short at the time.

MERLE HAGGARD: My Bible is moth-ridden.

BLEEDING HAIR CONTINUED

Speech, speech. Now that I have cleared the room I will reinvent myself. It's very refreshing to have this option. I have always admired those sorts of bargain-basement magicians who could pull rabbits out of their hats, chop their feet off, dye them pink, and sell them to children who believe in their luck. Then take the footless rabbit and sell it to an animal-rights group.

hepburn

the old man who worked the late shift as a bathroom attendent was a quick and meticulous cleaner. sometimes He would sit on the edge of sink and watch the ~~traffic~~ ~~of men~~ steady flow of men walking in and out of the bathroom. ~~Once noticed~~ He once ~~saw burt Lancasters penis once~~ on one particular evening He saw, burt Lancasters penis out the corner /of His eye.

a clover shaped THE cut Fingers of Fanny Brice mole

my funnest memory
is when i was
travelling with madonna
on the blonde Ambition
tour an i got to
meet CAT STEVENS

WiLLie elson

ERROR OF CONSIGNMENT

A. While thrift-store shopping with my sister, I encountered a white sweatshirt with bloodstains in the armpit area.

B. The lights in the shop blinked on and off three times in order to inform the Christmas crowd that the store would soon be closing. I was in a hurry to buy a used record player that I had just found, in perfect condition except for a missing needle. In the toy section, near the front register, a small boy with an amputated arm was playing with a plastic pirate hook and a broken walkie-talkie. He was wearing a gray scarf and Velcro sneakers. When I asked my sister if I could borrow her camera in order to take a photo, she looked around the store and told me to forget it, that the light was too dark and her flash wasn't working properly.

C. A dark-skinned black woman with tattoos on her knuckles was working the main cash register. As I walked by, I heard her say to the woman sitting beside her, "Anything beats prison."

D. A few feet from the used-shoe rack, an abnormally skinny man with dark spots on his face was looking in the mirror and trying on a white bunny-rabbit fur coat. It was only a matter of seconds before my friend Poncho told me that the man was gay and dying of AIDS. When I asked him how he knew, he said, "Just look at him, it's obvious."

Prelude | i had a strong impulse to retort that, on the contrary, everything about him was infintile

1. Steven was smaller than the other adults on the tour. In the bus one old man asked him if he had an extra battery he could use in his Walkman. Steven ran out of film before he could take even one traditional travel picture. He had entertained himself on the bus by taking pictures of everyone's shoes. (Steven stayed up for forty-five days on speed.)

2. Q: How old are you?
A: I was four.

he was sent in for 1st degree manslaughter

3. Q: For ten dollars would you rape her?
A: I'd rape her for free. But she's kinda big, might need your help.

4. to things i would like to be
1.
3. Billy Jean King

He wrote jokes for 65 years of his life
his wife wrote his obituary :JOKe
riddle

Harm

63

PHILIP BE QUIET: AND HARRIET MUST GO TOO

He was so nervous that when he entered the ballet studio he tripped on the wooden bench in the hallway. He always wanted to perform with the famous troupe but unfortunately one of his legs was just a tad bit shorter than the other.

See again Laughton's extraordinary *Night of the Hunter*. If you want to grasp what the film orphan is, the spectator's identification can't go any deeper than with the character of the orphan, the child alone in darkness.

—from Leo Carax's review of *Paradise Alley*

A NURSE TALKING TO A BURN VICTIM TWO DAYS BEFORE EASTER

NURSE: How do you feel? Can you breathe all right?

BURN VICTIM: It still hurts.

NURSE: Are the drugs starting to numb the sores a bit?

BURN VICTIM: It still hurts.

JOSEPH MOHR: Is there a man in the world who suffers as I do from the gross inadequacies of the human race?

LEONA UPTON: Go in and read the life of Florence Nightingale and learn how unfit you are for your chosen profession.

eating at a table accross the way from myself
i observed a fat couple eating a plate full
of shrimp. when the waiter walked over with
a pitcher of colathe couple began to pull
out tiny pieces of paper hidden in the pockets
of thier garments. on the pieces of paper
were written jokes and riddles. ~~the~~ The
waiter began to laugh at thier jokes.
After the fat couple finished eating
they walked out ok the resteraunt
and put two cloth surgical masks over
thier face.

IDEA FOR A LATE-NIGHT COMEDY

1. Walk out onstage wearing a navy blue suit with a tight gray sweater underneath, like an English schoolboy.

2. Begin to play with sleeve of my jacket, pull it back and forth and then stick my hand inside my coat pocket. (A few people in the audience will start to chuckle.)

3. Tell a two-minute monologue about getting my first haircut.

4. Smile a nervous grin at the audience. (The audience will fall into hysterical laughter. *Note:* By this time the audience should be completely won over.)

5. Recite three questions and answers from a printed interview with Whitney Houston from a 1986 issue of *People* magazine.

6. Throw both arms out to the side.

7. Play with my sleeve. (Heavy laughter.)

8. Say, "Jeez folks, you must forgive me, my sense of timing has been thrown for a loop."

9. Pick up a glass of water, take a sip, then spit it back into the cup.

10. Throw the glass on the floor and smash it so hard that shards of glass go flying into the audience. (A few people in the back will start to clap.)

11. Do a small tap-like shuffle.

12. Waltz offstage like Bing Crosby.

*For maximum effect: dim the lights. This act should take place in under 3 min. 25 sec.

tennis movie

1. Boy shows girl his scabs.

2. Boy plays tennis

Bowery Boys

Leo Gorcey Huntz Hall
Bobby Jordon Gabriel Dell
Bernard Gorcey David Gorcey

i met a pervert in the park ~~Hetor~~ He told
me his favorite movie is called the
'Chicken chronicles.' starring a young Steve Goutenberg

a man falls in love with a girl
he can't have. he films her in a
garden. THE man projects her image
and begins to kiss the wall with
her face bein projected on it.

rumors

1. Joan Baez is allergic to air
 conditioners
2. Maralyn monroe dyed her muff.

Robert Frost Bite

RUMORS

1. ████████████████████████████████████

2. Jessica Tandy had an elongated vagina.

3. Dom DeLuise choked on a birthday candle.

4. Ray Bradbury had scoliosis.

5. John Ford snorted cocaine and liked to fuck obese black women.

6. Dostoyevsky used to watch his wife shit. He would take notes on her facial expressions. He would look out his window and cluck like a chicken. His housemaid Clara just thought it was the pet chicken that they used to keep chained up in the basement.

7. Robert Benchley used to wear leather loafers half a size too small.

8. Toulouse-Lautrec was a dwarf from being inbred.

9. Harry Belafonte's brother Nick has a split lip and wrote a book on barbeque.

10. ████████████████████████████████████

11. ████████████████████████████████████

12. G.G. Allin voted for Jimmy Carter.

13. Mel Blanc once got in a fight with Johnny Carson over a potato latke.

14. Fred Savage eats frogs' legs.

15. Tim Buckley had diabetes.

16. Ray Harryhausen suffered from arthritis.

17. Walter Benjamin used to light firecrackers when no one was looking.

18. Johnny Rotten collects baseball cards.

19. Karl Marx used to play the viola.

20. Henny Youngman had a hangnail for three and a half years before getting it removed by a doctor.

21. Tom Petty has a dirty fish tank.

22. Placido Domingo likes sherbet.

23. Chris Burke worked as a janitor in a Unitarian church.

24. Henry Fonda owned stock in Honda.

25. Stepin Fetchit was the founder of MENSA.

26. Matty Rich eats chicken five times a week.

27. Ted Danson used to take tap lessons in college.

28. Freddie Prinze was molested in the Boy Scouts.

29. Leon Spinks played bass in a funk band.

30. Gene Autry named his daughter Cliffy.

31. Dan Seals flew to Europe and broke his foot.

32. Captain Lou Albano is a eunuch.

33. Roberta Flack is scared of going to the dentist.

34. Andy Kaufman used to put salt on his ice cream.

35. Marcello Mastroianni once got in a fistfight over a lost bottle of disappearing ink.

36. Gena Rowlands used to cry in the shower.

37. Jerry Garcia tongue-kissed his older sister on her deathbed.

38. ▬▬▬▬▬▬▬▬▬▬▬▬▬▬▬▬▬▬▬▬

39. ▬▬▬▬▬▬▬▬▬▬▬▬▬▬▬▬▬▬▬▬

40. Jackson Pollock had a foot fetish.

41. Diana Ross hated the movie *When Harry Met Sally*.

42. Montgomery Clift woke up one morning and had trouble moving his legs.

43. Emily Brontë used to ride her horse to a special place on the side of a mountain. She would sit and eat her licorice and dream of far-off places.

44. Loni Anderson's younger brother likes heavy metal.

45. Gertrude Stein was disgusted by her own appearance. She wore scarves in the summer.

46. Red Skelton thought his surgeon was a lush.

47. Greta Garbo had a schizophrenic uncle named Cromwell.

48. Elizabeth Taylor is a beer enthusiast.

49. Robert Wise hated the smell of fish and the smell of his wife's bottom private.

50. Irving Berlin married a redheaded Polish girl with no domestic skills.

51. Flavor Flav is a classically trained pianist.

52. ▬▬▬▬▬▬▬▬▬▬▬▬▬▬▬▬▬▬▬▬

53. ▬▬▬▬▬▬▬▬▬▬▬▬▬▬▬▬▬▬▬▬

54. ▬▬▬▬▬▬▬▬▬▬▬▬▬▬▬▬▬▬▬▬

55. Danny DeVito is clairvoyant.

56. Kirk Douglas collects Pez dispensers.

57. Pauline Kael has never seen hard-core porn.

58. ████████████████████████

59. Kirstie Alley was a Girl Scout

60. Townes Van Zandt fucked a sheep when he was fourteen.

61. Isadora Duncan once scolded a homeless man for having a swastika tattooed on his forearm.

die
die
die
~~i can always~~
die
die
die

i was goin to die by my
own hand and god
jumped on me he said
pull the trigger if you
want i wont be angry
its ok to kill yourself
a young kid should not
kill oneself but god said
go ahead make my day
what could i do then

Harm

BL: Enough about bugs. It may disappoint some people who want to see you as a bad boy that you're not really at a place anymore where that's relevant – that you're less likely to express your anger in a (more Depp page 127)

(continued from page 92) way you might have done before. Do you know what I mean?

JD: I've never thought about any of that stuff. We all have to do what we think is best for us. We all have to survive and keep walking forward through all the obstacles. The fact that I'm not getting heavily polluted anymore and self-destructing with substances—all that doesn't mean that I'm Mr. Conformity now, 'cause I probably am not. I'm not better or well, although I'd like to be well, whatever "well" is. It's all a big crapshoot.

BL: Do you have anything invested In not being a conformist?

JD: I just don't... I'm not going to play the game just for the sake of winning, whether it's the Hollywood game or the nice-guy game or whatever game it is. I just want to do what I want to do. And if it works within my career, then great. If it doesn't, fuck it. I won't be a slave to success.

DOG ENTRY #3: A LOOK WARM CONNECTION

B. Two beautiful golden-colored chow chow dogs were resting under the seat inside a moving passenger train en route to Stamford, Connecticut. The lady sitting behind the dogs whispered to her husband, "They're so beautiful." She got down on her knees and stuck her hand under the seat. It was her intention to pet the paw of the chow. But the dog was not interested. One look at the woman and both dogs got up and moved. The woman said to her husband, "Snob dogs." The husband smiled and then pointed to the dirt that had collected on the knees of his wife's trousers.

OWNER: I still have trouble getting him to obey.

BREEDER: Who? The dog or your husband?

OWNER: Both. *(Laughter. The owner exits the barn and collapses onto a bail of hay.)*

C. In the early 1940s Howard Hughes had a big chow named Chang. Chang got into a fight with another dog. When Hughes tried to separate them, the other dog bit him on the penis. It took six stitches to sew up the wound. Although it temporarily disabled him, the injury didn't seem to have any lasting effects. However, Hughes never owned another pet.

OWNER: How big was your litter this year?

BREEDER: Oh no, I never litter.

ENCOUNTERS A NOVEL

1. When the good-looking man tore the buttons off her dress in the midst of a heated sexual encounter, the first thing that went through her mind was, "How much will it cost to replace the buttons?"

2. The longest novels are the ones that will be remembered: *Don Quixote*, *The Brothers Karamazov*, *War and Peace*, *David Copperfield*, *Moby Dick*, and Proust's *A la recherche du temps perdu*.

3. Dickens was incapable of writing propaganda. His wife was a heavy drinker, so it didn't really matter to him. He was content watching her vomit into her shoe.

4. I met an English professor in a bar. He told me that I should read a book called *Efforts for Social Betterment Among Negro Americans*. When I told him I had already read the book, he bought me a glass of whiskey.

TUPAC SHAKUR'S TEN FAVORITE NOVELS

1. Antonin Artaud: *Van Gogh: Suicide Through Society*.

2. Arthur Schopenhauer: *The World As Will and Representation*.

3. Louis-Ferdinand Céline: *Journey to the End of the Night*.

4. Sigmund Freud: *Moses the Man*.

5. Alfred Doblin: *Berlin Alexanderplatz*.

6. Joris K. Huysmans: *Là-bas*.

7. Jean Paul: *Siebenkas*.

8. Johann Wolfgang von Goethe: *Elective Affinities*.

9. Burrhus Frederic Skinner: *Walden Two*.

10. Djuna Barnes: *Under Milkwood*.

DON'T REST ON YOUR LAUREL AND HARDY

(In a British hospital.
Igor the amputee is nine years old.)

DOCTOR: What time did you wake up today?

IGOR: Don't know.

DOCTOR: You don't remember.

IGOR: Early. I woke up early.

DOCTOR: Did you go to school?

IGOR: Yeah. I made something for Momma.

DOCTOR: What was that?

IGOR: A birdhouse. I made it with cotton balls and Popsicle sticks.

DOCTOR: Oh, that's very well. Are you good at building things? Are you good at those sorts of things?

(Igor the amputee shrugs.)

DOCTOR: Do you like to build things like the birdhouse?

IGOR: Yeah. I like to make rings for my fingers.

DOCTOR: Rings? You make rings.

IGOR: With clay—I make them.

DOCTOR: What's the first thing you're going to do when you get your new arms put on?

IGOR: I'm going to cut my own sausage.

(The doctor smiles.)

DOCTOR: You like sausage do you?

AMPUTEE'S MOTHER

When he first came into my life, I was immediately drawn to
him. I was immediately his mother, and I know that he could
tell that I was his mom. It didn't take long, the bond was
there for us in the first seconds. And when he was very, very
little I would take him in my backpack. I had seen a television
special, it was on the news, about a zookeeper who adopted a
baby kangaroo because its mother had abandoned it. And the
zookeeper had to keep this baby kangaroo in a blue ruck-
sack. So this immediately reminded me of Igor and myself,
because Igor's mom had left him in much the same way. So
I made a very small sack by hand that I fashioned with a soft
furry material on the interior so that Igor could be warm and
comfortable inside. And when we would go shopping together
all the other moms in the store would come up to me and say
how cute he was, but because he was in the sack all they could
see was his smiling little face bobbing out. He looked con-
fident inside, they couldn't tell that he had no arms because
he was tucked in so nicely. That's when the mothers were
friendly, when they didn't know what Igor really looked like,
how he was physically. But we all knew that when Igor grew
older, he wouldn't be able to fit on my back anymore, that he
would eventually have to grow up. This was very hard for me
to accept. Sometimes I think it was more difficult for me than
it was for him. I could always judge the times in Igor's life by
the changes in the expressions of the faces of other mothers,
the ones who didn't know Igor well, or the ones who were
witnessing him for the first time with no explanation.

stop that joking around

oh why is that a sensitive spot

+

just listen to reason

██████████ (1) no keep on playin

the piano com poser

=

it is loosely based on his life (very loosely)

+ -

still they left out the gay parts

—————————————

must we pry so deeply

this is man's purpose/pot to purpose/pot to piss in

<u>yes I am</u>

that is the point=pointless=pointillist vision

gay gay gay

gay boy

game boy

<u>i'm game boy</u>

play game boy

© influence buyers soon to be nike flyers

RUTHERFORD HAYES: I live in a town that is based on the principles of segregation. For the longest time my father had been trying to get me to play the piano. It seems that everyone in my family is in some way musically inclined. My two sisters both play the oboe, my mother the piano, brother the guitar, and father plays all the instruments but has a great fondness for the fiddle. On holidays and other special occasions, we all get together in the living room and play a concert of sorts. Some of the black people in our area gather at our property line in order to hear a trace of our family jingle.

It is my intent to live life like Horatio Parker, a noble man whose artistic contribution to school music expressed his faith in the musical future of our people.

Fifth book - morning glories - a class too fruitful - 92

Not a
study -
song

1- before : open drowsy eyes
the little morning glories rise to
climb thier ladders green and tall
that lean upon the garden wall.

Leona Upton - My boy was burned in a great
fire.

Joseph Mohr - Did: he die?

Leona Upton - yes. (She begins to cry.)

Joseph Mohr - then how my dear could the fire
be great?

IDEA FOR A MOVIE ABOUT
TWO BROTHERS AND A MOTHER

A blind boy and his older brother live together in a small house with their middle-aged mother. The older brother takes care of his blind brother. He walks him arm-in-arm to the grocery and back and forth from school. He tries to teach him how to play basketball. One day the blind boy recovers his eyesight. The blind boy begins an affair with his brother. The mother freaks out. The blind boy kills himself. The older brother and mother are stuck together.

1973 — RIP ~~dead body and Arboretum Friends~~

Foster a book ~~of piano~~

THIS SCENE INVOLVES A GIRL
WITH A NECKBRACE

A man and a woman lie restlessly in bed, unable to sleep. The
man is Chinese and his teeth are very white. After a long
time of pleading, the man insists that she sings him to sleep.
She is embarrassed but he keeps insisting. One of his toe-
nails is long and he starts scratching the side of her leg. He
promises that he will not laugh at her. She gives in and sings
him a lullaby. Her voice is a bit awkward perhaps. Toward the
end of the song the man breaks out in uncontrollable laughter.
She stops singing and looks at him. He says, "No, I'm not
laughing at you."

WOMAN: What?

MAN: No, no, it's nothing. I just thought of something funny,
that's all. Keep going.

(He begins to laugh again.)

(She drops her head on the pillow.)

MAN: I'm sorry, I'm not laughing at you.

(He puts his arm on her back.)

Tess's feeling a pain in her side.
She is sick of the cleansing report.
When her collapsed lung forged
ahead and she placed a song
on a bet that the horse would
die. her early morning death couldn't
keep the ~~their head~~ townspeople
from mourning. The governer came
to show his respect but for Tess
it was too late, their showers,
hit her a false note.

CHALLENGE FOR HIS DEMISE: IN HIS GRACE HE FALLS FASTEST

For the first time he lived with a girl and slept next to her every night. He visited his parents and slept next to his brother in his bed.

UPON HIS RETURN: I would ask her for trouble on a night like tonight. But the snow is thick. I would dream to murder her in the thick of it all. No matter what the sound of her pleasure or pain. I could grin it away. With my master next to me. You can't tell me no.

(His written statement.)

CHALLENGE THE SMALLER DISASTERS: IN THE WAKE

(He's overweight and he's wearing shorts.)

As he tells me a story he picks a scab on his leg. Blood pours down his shin. "Damn mosquitoes. I just bombed the place. It takes a lot to stop my blood."

He started a friendship with a woman. The house was now full of children. On those rare moments the toddlers would strut naked across the field to throw darts at the tree.

WOMAN: Look, the children need pants today.

1. a holy bark

2. if you pass in the seasons it's only for his greetings.

3. He was proud to have ruined the family.

KANSAS CITY HIGH

1. Where we're from the only way out is death.

2. Is it true that death is a penalty.

3. Heaven produces no great works.

Sister is sick, and for the first time I wish to stay happy. It went under the subheading of medical. He fattened himself with these thoughts.

A CONVERSATION BETWEEN
JIMMY DURANTE AND A KID OFF THE STREET

KID: Jimmy, do you speak French?

DURANTE: Si, si.

KID: That's Spanish.

DURANTE: How do you like that? I speak Spanish too.

There was only one black girl in my high school and her last name was White.

He felt he was a complex character. Perhaps worthy of a novella. His fifth-grade teacher found him simpleminded and boring. She was a dyslexic.

A DAUGHTER TO HER MOTHER

Shoot, that ain't nothin', if I was gonna sneak out the window,
I'd juss go through the front door.

My girlfriend has herpes and her mother has lung cancer.

PART TWO

SWAN SON
OF THE SPICK

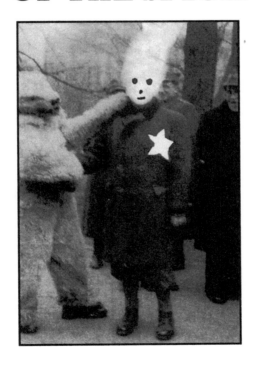

LEONA UPTON: My boy was burned in a great fire.

JOSEPH MOHR: Did he die?

LEONA UPTON: Yes. *(She begins to cry.)*

JOSEPH MOHR: Then how my dear could the fire be great?

JACK PAAR: THE TRAGEDY OF '78

My mother was a manic-depressive. She used to sleep for weeks at a time. There was plenty of pain in my life. But that is nothing special. Everyone has it: children, dogs, pets, doctors, lawyers; it doesn't matter. Hurt is universal, so is making people laugh. I can tell you about my fat, Spanish next-door neighbor. This guy had a scar on his forehead that was extremely prominent. One evening he called 911 for help. He wanted to die but he wanted to talk. To talk and to die, see. When the police came to rescue him he was waiting for them on the front porch. They said, "Hey, what's the problem Pedro?" "Get away, I'm gonna die," he said. I know how he felt and all, wanting to die, but wanting for people to see him on the porch. He had a razor blade in his mouth and he kept taking it out and showing it off. Moving it around, back and forth. He said he would swallow it, he wanted to swallow it. It was in his mouth when he said this. And the cops they waited till he showed it off again and then they hit him on the wrist with a flashlight. He cut his lip up and they started to beat him. He kept saying, "I just want to die." And they knocked him in the head. They said that they were going to take him to the hospital and that everything would be OK. He kept saying, "My lip, man, my lip." This was around the time when my youngest sister was thrown out of prep school for being a thief.

HAIR BETWEEN YOUR TOES, MOMMA'S A BLEEDER

(Over the phone.)

SIDNEY: I saw your girlfriend at the airport.

TEMPLE: Oh yeah.

SIDNEY: Is she Italian?

TEMPLE: No, she's from Cairo. She's a direct descendant of King Annabar-Sissbo.

SIDNEY: She looks a little like Lorretta Lynn. What's her name?

TEMPLE: *(Panting and out of breath.)* Her name is Faver.

SIDNEY: What's wrong with you?

TEMPLE: Nothing.

SIDNEY: Are you sick or something?

TEMPLE: It's a bad time, to be honest with you.

SIDNEY: Why?

TEMPLE: 'Cause right now I'm in Faver.

IN TITS

It's not unlike him to go every Sunday to the homosexual outreach program, four blocks from his house in the basement of a church. This is a place where he can let loose and meet other gay people with similar interests. The first time he went there, he brought a bowl of egg salad with him. He had just broken up with his boyfriend and was feeling alienated. A friend of his brother, who was also gay, told him what a cleansing experience it had been for him after his boyfriend died tragically in a drunk-driving accident. It was not his intention to use the program as a pickup device but he couldn't help himself. There were three fellows who he said he could imagine being romantic with: they were all brunets. One of them was an ex-pro basketball player who had five children by two separate wives; he had a sexy trim body. The second time he participated in the program was on Easter Sunday. The man who ran the program gave a small religious sermon before. On the way out of the church the men walked together in one large huddled group. A young black man was sweeping the floor, and as the group staggered past him, he looked toward the water fountain and said, "I ain't never had any trouble with homosexuals. They ain't never bothered me, and ain't never bothered them." Then the group of gay men began laughing and stroking each other.

SUICIDE NOTE # I

It was never my intention to molest little Sammy. I have suffered more than you can possibly imagine. I do not know why I had the urges that made me act this way. All I can say is that I never felt exactly normal. I used to sit at home and cry to myself. "Why me, why me?" There is no excuse that I can give that will satisfy anyone to the point where they will understand my reasoning. I know Sammy will never be able to forgive me and he will probably never fully recover from what I did to him. When I was a child I was abused in every way imaginable and I realize this whole cycle of molestation is a repeating process. When I was a child in school and the teacher called out my name to tell the class how I spent my summer or what my hobbies were, I always had to make stuff up, I was always covering my tracks. It was so hard to live that way. I only wanted to be normal or at least to appear normal to my friends but they still knew. How was I supposed to feel when I was being raped and there were bloodstains in my small white underwear? And instead of doing something about the situation Mother would just try to bleach the bloodstains out with detergent. She didn't even care enough to buy me a new pair or ask me if was all right. I would look at my butt in the mirror and just pray that it wasn't torn off. I can't tell you how sad I was. How can a child grow up to be healthy in this sort of environment? I don't want to blame anyone. I would just like to say that I'm sorry to Sammy and that he doesn't have to turn out like me. I realize what I took from him and maybe, in some strange way, this will give him a bit of it back, a small bit of satisfaction.

signature

SUICIDE NOTE #2

Dear World,

Fuck all the foul-mouthed girls who invade my land, it's filled with cheaters and infidels. Maybe you were right: maybe I am a monster. That's why I will die by my own hands, because all creatures not of this earth will perish in a blaze of glory. I will be sitting at the altar of God. He has claimed my soul. Die! Die! Die!

signature

SUICIDE NOTE #3

The first time I tried to kill myself the intent was not to succeed. I wanted to fail, get attention from her. I wrote her a letter today, but I know it will take at least 4 days to get to her, seeing how she just moved to Alabama. I just don't have the time or patience anymore. Today, I still feel a bit hesitant. I saw a picture in my history book where they had just hung a slave from the neck. He was so thin, he had been stripped down to his underwear and his neck was so crooked that it was lowering from his body. The caption under the photo read, "Kentucky slave nicknamed 'Butterhead' caught pocketing one of his master's books." Someone scrawled under the photo "Butterhead's melted." I was wondering what book he had stolen and if it had taught him anything. I went to the library and read a few pages about bullfighting. The bull never wins. This is the history.

<div align="right">signature</div>

SUICIDE NOTE #4

First things first: I would like to set the record straight. The reason I am hanging myself is not solely because I am a midget. Two days ago while I was visiting Vancouver I went to a hockey game and I got so upset at myself because I realized I would never be capable of being what I wanted to be. This is obviously due to my stature; I am unable to go out on the ice and compete. I spent four hard years of my life writing what I consider to be one of the greatest romance novels of our time (*Please Consider My Lust*), of which I have now burned the only existing copy. No one would give it a fair read. There was not a single reply, even from the people whom I consider to be close personal friends, not naming names, they never got around to reading it. All I can say is to hell with this life. Plus I am only attracted to tall women, these are the women who time after time consistently refuse me. Do they ever give me a chance? No. Do they even care? No. My only regret is that I was never able to visit Sweetwater, Florida. I have always wanted to go there because it is a town that was originally settled by a troupe of Russian circus midgets in the early 1940s. My parents were married there and I was conceived there. I leave all my belongings to the NAACP, except my art deco wall clock, which I would like to leave to the Dayton, Ohio, public library because this was the place that I first discovered the works of Emily Brontë and S. E. Hinton, whose works inspired me to become a failed midget writer.

signature

SUICIDE NOTE #5

There are many who dare not kill themselves for fear of what
the neighbors will say. —*Cyril Connolly*

No matter how much a woman loved a man, it would still
give her a glow to see him commit suicide for her.
 —*H. L. Mencken*

If I were not afraid my people might keep it out of the news-
papers, tomorrow, should commit suicide tomorrow.
 —*Max Beerbohm*

Suicide is belated acquiescence in the opinion of one's wife's
relatives. —*H. L. Mencken*

More people commit suicide with a fork than with any other
weapon. —*the Bible*

See you later.

 signature

SUICIDE NOTE #6

The dead are a heap more trouble than the living, the stranger said. That schoolteacher wouldn't consider for a minute that on the last day all the bodies marked by crosses will be gathered. In the rest of the world they do things different than what you been taught.

<div align="right">signature</div>

SUICIDE NOTE #7

I walked up to the bank near Central High School yesterday
and there was this attractive black girl at the counter. I had a
fuckin' pistol in my pocket and I thought to myself, goddamn
I'm gonna rob this fucker. My problem is that ten years ago
I would have been fearless, I would have gone up to her and
torn her face off with no remorse, like the time me and Nicky
robbed the bowling alley and Nicky got sent up for eighteen
years. Damn man, I was fearless and Nicky never was the
snitch. A cold killer with a heart of roses, he always confused
the hell out of everyone for that kind of thing. We were like
in the Old West days, Nicky was bad-ass. I'm gonna come
clean too, 'cause I know that you know that I got your sister
pregnant, Nicky. Everyone does. I mean for God's sake, the
kid and me we have the same identical face. I guess I just de-
nied it for fear of responsibility, you should have known, you
might have, but I have always had no sense of responsibility.
Remember when we got that little puppy a while back (I think
his name was Jerico or some Indian shit) and I gave it about
ten palmfuls of beer and it got drunk and poked its eye out on
the table. I have been incompetent since day one but always
a damn good crook. But man it's all starting to leave me now.
Like my dad used to say, "A man is old when his dreams about
girls are reruns." I hate livin' reruns, but what can I do man?
My nerves went south. It's time to go when you lose your
nerves. I have thought hard for the last three days about the
best way to do it. I looked out the window this morning and
saw some short fellow trimming some trees and all I did was
dream about jumpin' into that annoyingly loud machine that
turns branches into saw-dust chips. Wouldn't that be a fuckin'
kicker, my dirty ass in pieces all over the neighbor's front
yard? I know one thing: I'd definitely make the papers, but
this time people would say, "Damn, I didn't know the fellow
had it in him."

signature

105

SUICIDE NOTE #8

This is the absolute worst time of my life.

<div style="text-align:right">

signature
</div>

SUICIDE NOTE #9

There is very little room in this world for lesbians. I regret not having spoken to my parents all these years. The one time I had sex with a man was in high school, this is something that no one knows. I loathed the experience. Mr. Lowse, my A.P. English teacher, peppered me with compliments, but it was difficult for me to understand these sorts of things. After school was practicing my speech for the debate team, and he showed me a picture of his ex-wife who he said he had been married to for thirteen years and had never gotten over her. So when he showed me the picture I saw that she was as fat as a house and then I knew what he wanted. He was so gross!!!! It wasn't that I was even attracted to him, but in the core of my gut I felt honored for some sorry reason. He was whispering in my ear and just staring so deeply into my eyes. Even then I knew he was just perpetrating but I guess at the time it didn't matter so much. He fucked me on his wooden lecture table after he slammed the shades down. He looked so exhilarated that I got kind of frightened. I couldn't imagine anyone getting this puffed up about doing it with me. He fucked me for about three minutes on the table, my head was knocking books onto the floor. I looked up at his ugly crooked face and he goes, "I'm gonna come inside." He said it about three or four times in a row. When he was finished, he pulled his dick out; he looked a little bit choked up. I looked at him and I said, "Mr. Lowse, you just fucked my belly." I was still calling him Mr. Lowse after all this. When I got home, needless to say, I felt shaken up and confused. I stripped off my clothes in a hurry. My belly was completely crusted up. I remember this took place a day before Memorial Day weekend. That Sunday I was watching TV by myself and the back of my thigh was irritated. I went to the bathroom and saw that it was a splinter and I immediately flashed on Mr. Lowse's wooden desk. I just collapsed on the floor and bawled my eyes out for at least half the day. That's how it hit me. And

now so much has changed and that all seems a long time ago, and it is, but I feel the world should be rid of people like me. It's not a natural thing to be a lesbian; God intended people to procreate and live in a somewhat normal fashion. As for my weight, well I've always been heavy. For the past year I've been having to wipe my ass with a medical scrub-brush. I am putting all this stuff in here because I want to come clean. No one is ever honest anymore; they never say what they feel. I just want to put it out there for everyone. I identify with the fat character in the movie *Full Metal Jacket*, when everyone beats him up with soap bars while he's sleeping. On my tombstone. I would like it to say, "God's Mistake."

<div align="right">signature</div>

SUICIDE NOTE # 10

Been drunk all day. So what! I've lost my happiness — gone
in a troika careering into silver mist. Had laid down with
a woman whose bosoms resembled an accordion. The hour
came, you left the house forever. I hurled the ring at your
swollen ass. You laid your life in the hands of another, and
I forgot your cheekbone's lovely arc. I am nailed to the bar
with liquor.

signature

SUICIDE NOTE #11

Mother, I am in love with you. When Dad used to paw on you when I was little, there was always some uneasy feeling there. When I went out with Tammy, you got mad because she was half-black. Well I felt like saying if you're so upset with me why don't you just love me, and I don't mean the way an average mother loves her average child. I felt sometimes that you understood what I meant even if it was unspoken. I also felt that you felt a tad bit the same: you used to watch me dress for school in the morning and I could tell you were looking at me, sometimes longer than a normal parent. I hope that you quit working at the pet store and get another job where you're more happy. I will always love you, Mom.

Your Son-shine

signature

110

i asked my girlfriend to rent
a porn movie. She thought it would
be cool to rent a gay one.
i was so turned on it was
Like being reborn,

so what happened?

dont laugh but i figured
out i was gay and i
threw her ass out on the
street.

JOSEPH MOHR: Should I commit suicide or get a tattoo?

LEONA UPTON: Oh don't do that.

JOSEPH MOHR: What? Which one?

LEONA UPTON: You shouldn't kill yourself till you've lived longer.

JOSEPH MOHR: I should get a tattoo then?

LEONA UPTON: Yes.

JOSEPH MOHR: If I get one it'll say "Oldtown."

LEONA UPTON: "Oldtown"?

JOSEPH MOHR: "Oldtown" is the name of the shopping center that my father used to take me to.

THE POWER OF A MUCKER
AND HIS HOME JOURNAL

When I got hepatitis B, the first thing I did was walk to my
mother's house from the clinic. I walked into her room and
she was in bed reading a *National Geographic*. I told her that
I had been diagnosed with hepatitis B, and in the very short
time that it took her to react I noticed a black-and-white
photo of Nancy Reagan that had been torn out of one of my
mother's magazines, and it seemed to me that Nancy had
had many plastic-surgery operations done to her face but her
hands were still wrinkly and there were numerous age spots.
It was surprising to me that the president's wife had allowed
her hands to age that severely.

BARBER: If you are asking me for my opinion, then what I'm telling you is that the new style is lines shaved on the sides going parallel with a single slanted line shaved into the eyebrow, and let the length play out in the back so that it drapes the shoulders, with absolutely no trace of sideburn.

THE KILLING OF RANDY WEBSTER

(The phone rings. Father gets up from the dinner table and answers the phone.)

FATHER: Hello.

(Mother sips water out of a wine glass and stares upward toward the chandelier.)

FATHER: He was killed two weeks ago.

(Mother looks down at her plate.)

FATHER: *(Still on the phone.)* That's all right.

(Father hangs up the phone and sits back down at the dinner table. He looks at his wife.)

FATHER: That was the army recruiter.

CONVERSATION BETWEEN SKEEZER, A NINETEEN-YEAR-OLD CRANK DEALER, AND HIS EX-HIGH SCHOOL LIBRARIAN: OKLAHOMA, 1996

SKEEZER: I read that book you told me about.

LIBRARIAN: Emily Dickinson?

SKEEZER: Naw I read, uh, what's it called, *The Great Gatsby*.

LIBRARIAN: Fitzgerald.

SKEEZER: Yeah, F. Scott Fitzgerald.

LIBRARIAN: Did you like it?

SKEEZER: Yeah, it was pretty good. I like reading all that shit about the rich.

LIBRARIAN: You got any crank left?

SKEEZER: Yeah. I got some fuckin' shit from Davey's little sister. Some decent bathtub crank.

LIBRARIAN: Davey the Mexican?

SKEEZER: Yeah, his sister's got some pretty good shit. In fact, I've been tweakin' on it for about five days an' shit.

LIBRARIAN: It's good?

SKEEZER: Hell yeah, it'll keep ya up an' shit. That's how I read the book. *The Great Gatsby*. I was speedin' so hard an' shit the pages were just turnin' and my eyes were wide fuckin' open. I probably could've read two or three books back-to-back. You don't blink or nothin'.

LIBRARIAN: I guess I'll get some.

SKEEZER: Cool, cool. Maybe I'll read that Emily Dickinson bitch tonight if I don't go out.

LIBRARIAN: I kinda need to hurry 'cause Ann is waiting for me with supper.

EMILY DICKED HER SON

49

Angels — twice descending

reimbursed my store —

burglar! Banker — Father!

I am poor once more!

1858?

STORY AND VISAGE:
IN AN AIRPLANE THEY SAT AND CHAT

Two women who were obviously lovers were sitting side by side on an airplane. They were both wearing khaki shorts. One of them was older and her voice was deep like a man's. They both wore their hair chopped and sticking straight up about two inches longer than a crew cut. The younger of the two was wearing a PGA golf shirt and what looked like boys' leather dress shoes. The older one had chapped white knuckles and brown freckles going up her forearm.

OLDER: Can you imagine when we get to Indiana, how Sandy's going to react?

YOUNGER: If she tells me I'm stupid I'm just gonna get up and I don't know what.

OLDER: I'm tellin' you.

YOUNGER: I'll probably spend half the trip calming her down.

OLDER: At least her gift will put her at ease. That was a good idea even if she is selfish. She is so selfish it's unfathomable.

(A pretty black stewardess pushes up a drink cart.)

STEWARDESS: Hi. Are you thirsty?

YOUNGER: Yeah. Do you have Shasta cola?

STEWARDESS: No, I'm sorry. We have Coke, though. Is that OK?

YOUNGER: Sure, it's fine.

OLDER: Do you have Sanka?

STEWARDESS: Yes we do.

TWO CUPS OF YID = A SAD AND LONELY GAMBLER

1. I got enemies in high places — *Howard Hughes.*

2. White momma Bette Davis was brave.

3. Dudley Moore's blood level...

4. Joan Baez peanuts.

5. Louis was proud that he had Armstrong.

6. Andie MacDowell, John Keats, and Leslie Nielsen.

7. Norman Bates walks with a limp dick.

8. James dead stole.

9. Lenny Bruce was a bore.

10. Andrew McCarthy — God bless his soul.

11. Mae west go east.

12. Oppenheimer believed in rape.

13. Marlon Brando.

14. Jodie Foster doesn't believe in molestation.

15. *The Brady Bunch* father got AIDS from sipping blood. Rock Hudson too.

CONVERSATION BETWEEN
TWO FREE SPIRITS FROM KENTUCKY

SPIRIT 1: My grandmother's name was Gladys.

SPIRIT 2: Like Gladys Knight and the Pips?

SPIRIT 1: Yes, in fact it's funny you mention that, my grand-mother was a great singer in her own right. She wasn't famous, but in our family she was famous for her singing voice.

SPIRIT 2: Is she still alive?

SPIRIT 1: No, she died when I was a boy.

DON'T CRITICIZE THE DONOR

My mother was sick of not knowing what the date was. She woke me up early in the morning and gave me money to go out and buy a calendar. I went to the bookstore down the street from my girlfriend's house. There was a funny-looking bald man who was at a desk signing books for a few dozen people; he was wearing a bow tie and white cloth gloves. I couldn't understand why he was signing books so early in the morning. I went to the discount section and bought a Civil War calendar. Abraham Lincoln was on the cover. I stood in line and waited for about fifteen minutes so I could ask the guy to sign my calendar. "That's not my book, I didn't write that," he said. "Don't be silly, it's a calendar," I said. "It's just pictures." He smiled and then quickly signed his name on the outside plastic. When I got home I showed my mother the guy's name, but she had never heard of him.

1. I was a slow reader and a bad swimmer and I cannot tell you how much pain I experienced because of it. I ended up living in a tree house behind my parents' flower garden. The only time I was shown any sort of kindness was when I burnt my fingers on a candle; my mother loaned me her first-aid kit. When I got a little older I met a girl who worked at a movie theater; she was pudgy and her forearms smelled like buttered popcorn. I got her pregnant and she had an abortion against my advice to keep the baby.

2. I met a baseball player in an airport and he told me. "Resist not evil, but overcome evil with good." He was eating a piece of meat and when I asked him what his batting average was he told me he was still in the minor leagues. I asked him when he was going to turn professional. He told me. "I'm too nice to be a professional ballplayer. I couldn't even hit a fly." Then I asked him why his teeth were so yellow and he paused for just a second and then replied, "Who knows, maybe it's 'cause I been chewin' tobacco since I was twelve, that's a long time, almost fourteen years." He said, "I knew this one pitcher who got arrested for chewing tobacco. One day he spit and drowned a midget."

3. "...that (in INTOLERANCE) he was not attempting to follow the accepted ideas of continuity, but rather offering his themes in a development much the same as thoughts flash in one's mind."

—Ibid.
(Walter Benjamin after he turned
Zionist and homosexual)

THE SPORTING LIFE: LIFE OF A YACHT

There were several deaths at the boat show this year. It was
a depressing season because the yachts collided during the
exhibition. I had just called my mother collect from a pay
phone; she was on vacation in Germany. It was a surprise
when I heard over the intercom that the two most expensive,
state-of-the-art yachts blindly bumped into one another. The
captain of the smaller yacht, *Old Yeller*, was tossed into the
bow of the larger yacht, *Smiling Willy*.

MOTHER: *(Over the pay phone.)* I visited Auschwitz with your
father. It was the most horrible, most god-awful place I
have ever been. Everyone on the tour was crying. In the
front where you walk in, there are still the barbwire fences.
Everything there is kept original. The whole place is color-
less and gray. They opened a McDonald's right across the
street from the entrance. Your father's stomach was upset
so he didn't order; all I had was an apple pie and milk but I
couldn't enjoy it.

CHANGING BACK FROM THE GAY SIDE

MICHAEL: He was changing back from the gay side. You know, I was trying to take him out.

PAUL: Take him out where?

MICHAEL: You know, like strip joints and stuff. 'Cause the first time I met him he just admitted to me that he was gay.

PAUL: I knew he was, I could tell. I used to go to school with guys like him. Wealthy Long Island Jewish boys.

MICHAEL: No, no, that's just it. He's not wealthy at all, he's completely poor.

PAUL: He is?

MICHAEL: Yeah, he just looks that way. So neat and proper.

PAUL: How does he get those clothes then? How does he afford it?

MICHAEL: He's a waiter. He just goes to thrift stores. It's all an act. His clothes are all secondhand.

PAUL: Really?

MICHAEL: He is so poor. That's why he spent Christmas over here, he's never been to a real Christmas.

PAUL: Why?

MICHAEL: Because his family is so fucked-up, it's unbelievable. They have so many problems. His mother busted his father cheating with a twenty-year-old, um, what are they called? Those women?

PAUL: Mistresses.

MICHAEL: Yeah, his mom walked in on him and his twenty-year-old mistress on Christmas Day. So for the past eight years they haven't had a Christmas. His mother refuses. Also the mistress's name was June so his mother refuses to

acknowledge the month of June.

PAUL: I thought he was Jewish.

MICHAEL: No, he's not. He's a terrible alcoholic. He sleeps on the streets sometimes.

PAUL: Who? That guy?

MICHAEL: Yep, I promise.

PAUL: No.

MICHAEL: I know it's hard to tell because he acts so prim and proper.

PAUL: He wears argyle socks.

MICHAEL: He's just about the worst boozer I've ever met. Especially for a young person, you know.

PAUL: I just saw him drink wine.

MICHAEL: He'll drink anything. Even soup. It doesn't have to be alcohol. He can gulp down tons of soup.

PAUL: Soup?

MICHAEL: Like the place he works, they have really good soup. You know, fresh soup. But it's thick, it's the thick kind. And what he'll do is pour himself a humongous bowl and let it sit for like five or ten minutes so it cools down. Then he'll just drink like an entire bowl in like ten seconds. He just downs it. It's incredible.

Follow my casket ====

Suicide SOLUTION
Suicide SOLUTION b b

 b

take a piece of brain out of my
Head / suicid suicide — No way out
a parasite in this worLd / Feel
No more PaiN — Hurt is gone
suicide i CaN decide
Suicide i can decide
PLaiN PaiN — SimPLe SoLutions

it wiLL be over
and i can rest

Now my parents can rest/me too young PeoplesbLoo

THREE OR FOUR CLAIMS TO FAME

1. I only missed two days of elementary school.

2. I met Johnny Carson.

3. I got a compound fracture from jumping out of a moving car.

HER TWO FAVORITE CIGARETTE JOKES

1. He reminds me of a young "Chester Field."

2. He reminds me of a young "Benson Hedges."

The other day I heard a guy in a business suit yell at a barking dog, "Come on already, what are you doin', smellin' the roses?"

ME: I'll give you $1.00 if you hit her. I won't hit her for $1.00. I'll give you $2.50. Cinnamon sticks cost $2.75.

BETWEEN TWO VAGRANTS

VAGRANT 1: I mean I'm a Muslim, and I feel like lovin' Jesus.

VAGRANT 2: He's like that.

VAGRANT 1: He's compelling.

VAGRANT 2: Yep, that's why they call him Jesus.

(Anthony Quinn's sixth-favorite artist is Velázquez.)

OLIVER HARDY LOVES
VIRGINIA LUCILLE JONES

Laurel and Hardy were working on a movie called *The Flying Deuces*. They were in the middle of a scene when all of a sudden the script girl tripped over a radiator and bumped her head on an arc light. She was rushed to the hospital. Hardy discovered her good looks while she was unconscious. He courted her by sending a box of chocolates and a diamond ring. They married each other in 1940.

HARDY: Once I raped my landlord after I escorted her home from church one evening.

LAUREL: Oh Hardy, that is so shameful.

HARDY: Afterwards she made me tea.

(*Laurel walks to the open window and leaps out of the fire escape. When he hits the concrete, he shatters both his ankles.*)

1. Three years earlier, fifty-four-inch-tall fellow Geto Boy Bushwick Bill also contemplated suicide. Drunk on a potent white spirit called Everclear, he loaded his gun and went to his girlfriend's apartment. Bible-conscious and fearing a trip to hell if he fired the gun himself, Bushwick instead snatched his girlfriend's baby, and in the chaos that ensued, coerced her to shoot him. The results are recorded on the cover of the Geto Boys' 1991 album *We Can't Be Stopped*. It shows Bushwick Bill still alive, but nevertheless being wheeled down a hospital corridor on a stretcher in some pain, because his girlfriend had shot out his right eye. Following the incident, the rapper unsuccessfully attempted to sue the makers of Everclear for "aiding and abetting a felony."

2. "I hustled. Things I could do some serious years for," he says, looking back on those days. "To a degree all bad boys are homicidal *and* suicidal, 'cause they have so much disregard for life. If you're playing with death that much, where you're putting yourself into situations where other people might take your life, that's suicidal in itself. You struggle with yourself every single day. Your good side says, 'Get out,' but your bad side thinks, 'What's gonna happen if you do? I'm tired of begging for bus tokens.' It fries your brain cells. It's like being on a roller coaster. You're screaming 'cause you're enjoying it and 'cause you wanna get off."

PART THREE

LIKE A TURK
IN STOCKHOLM

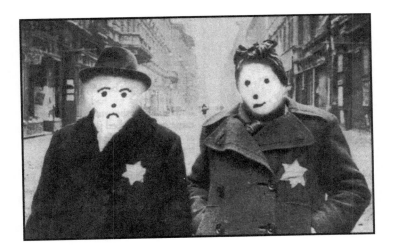

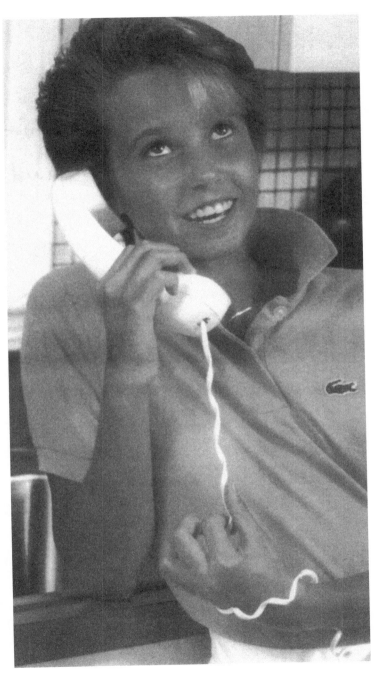

BILLY JEAN KING

a mistress is something
between a master and
a mattress.

THE TUPAC LETTER

Sup Nigga Floyd,

I haven't written in so long, I been watchin' baseball on the
set (I got the biggest TV you ever seen, the kinda boob that
when we wuz children they didn't even have shit like this, a
small movie screen with drink holders comin' out the side),
an the Braves is slamin' this year, mad homers an a fly infield.
When I was locked up you sent me music an I must tell you
lil' homie that shit kept my ass in check, some jazz, some
blues, an the rock shit was cool, The Who, I read the liner
notes about Keith Moon and that shit struck me for some
reason, I wrote a song based on his childhood called "The
Boy Trapped in the Moon," the beat is funky, that nigga Dre
Bone flew in the beats from his crills in Florida, we sampled a
buncha shit from Marvin Gaye an this crazy slide guitar from
a country album. I'm gonna tour a little bit with Snoop an
some others but I'm gonna be out your way real soon so get
ready. But listen yo I'm much calmer these days. I felt like I
been seein' the light burn bright as hell an that shit singed my
skin with the word *Righteous*, it don't mean I ain't no thugg,
that as you know is my destiny, but the time is time an my
ass is gonna sit back, rhyme, get hella busy with the bitches,
keep prayin' day after day, buy shoes, whatever, the impor-
tant thing is just livin' in step, the tragedy is yesterday's news
homie, that shit is straight-up *fin* as they say in the French
land. When I was shot I started having visions, I started re-
membering whole passages from books that my moms made
me read when I was a reluctant nigg, she made me read Mark
Twain an *Moby Dick* an shit an that shit was just poppin' into
my head like it'd been there the whole time stuck in the back
under a puffed-out haze of fog, whole fuckin' passages an shit
about the power of the light an the force of the sight. That's
why those East Coast pussies couldn't lay me down, the
thugg bone had too much force, them bullets was rendered

silly Lil' Floyd. I still gots problems an shit as you know, the typical and the anti-typical, it's hard for me as a man to show a woman respect, I feel I can respect her for a time, but then she just gives her shit up easy an I want to spit on her. I could be in love with her one moment and the next I'll hit her shit deep from behind an her face will make a certain grimace an the game's all over for me an especially for her, I'll turn her shit out like the devil, I don't know what's in me that makes me do the shit I do. That's the thugg in me, the thugg life story, or as Michael Jackson would say my (his)tory. I've turned out so many bitches that at one time or another I've pledged my love to, I'll give her to a nigga I fought years back, some dark-ass fool I busted way back in the day, I still don't like the muthafucka but I'll give a piece just out of whatever nonsense I'm feelin at the time. That shit is wrong with me but I'm young still. So much in me has calmed, the loot tends to make a nigga calm. I got a steamin' bowl of clam chowder coolin' off in front of me an they're playin' reruns of the Ali vs. Foreman match from 1974 on the sports-classic channel. Hug all the women I love. I'll be there soon, we can take your Bronco to the beach an rub up on some shit. Say thugg love to those in the hood, the 3–5 crosstown niggaz, Rd J., Da Fat Bitch Worm, Knocc Out, King Kennedy, Kerm, Angry Avi, 123 Hot Sauce Hustlaz, Archie Arch, Kiesha Anderson, and everyone else sippin' the sauce down at Kent College.

<div align="right">Thugg Life Survivor,
Tupac Shakur</div>

we called the sherrif
because she was thowing
rocks at Cassidys car

Kevin slept with his ex- girlfriends
mother

ETHNIC ATROCITIES: PICTURES CONTINUE

1. A thirty-year-old black woman is standing in front of an apartment building. She is holding a white towel around her hips with one hand. She is a bit chunky and her breasts are sagging. She has a large pair of glasses on. Her hair is short and cropped. She is also wearing large silver earrings. She looks a bit pregnant. There is a tree behind her in front of the building.

2. An old man with no shirt on is sitting on the hood of a small red car. He is holding a broken vial of lipstick. He has a flat chest and a large stomach bulge/beer gut. He is wearing cutoff jeans and cowboy boots. He looks old but devious. He has two teeth on opposite sides that are sharp. He has a messy gray ponytail that is being held back by a checkerboard bandanna.

3. A Spanish woman wearing a blond wig is doing naked jumping-jacks in her prison cell. She keeps screaming, "Lord, I think I have gonorrhea." Her armpit hair is neatly braided.

ACROSS THE STREET
FROM UNIVERSITY SCHOOL

*(On the steps in front of the cafeteria at
Vanderbilt University, Nashville, TN, 1983.)*

*(A petite bland girl in long shorts and dirty white espadrilles
runs down the steps with a tray of french fries in one hand
and a carton of milk in the other.)*

*(Pam and Jill watch her. They are both eating Caesar salads.
Pam has huge bosoms.)*

PAM: She reminds me of this one girl who tried angel dust one day in junior high school. She was, I guess, the first girl in town, or at least the first girl I knew of, who was into that kind of stuff.

JILL: What was her name?

PAM: I forget.

JILL: I know who you're talking about. Norma was her name.

PAM: Norma. That might be her. Her hair was in small tight curls and goofy.

JILL: She was a grade above us. We rode the same bus and her little brother used to have a ponytail. He looked really feminine.

PAM: I think I remember him.

JILL: I always respected him so much 'cause he never cut his tail off.

PAM: What happened to Jordy?

JILL: Jordy, I'm not exactly sure but last I heard he moved to Texas with his parents. Someone told me he was going out with this really bitchy woman who's a few years older than him. I think she has kids.

PAM: Are they his kids?

JILL: They're from a previous marriage.

(A dark-skinned boy in tight jeans walks by passing out flyers for an upcoming party at the Jewish fraternity. At the bottom of the page is a crudely drawn illustration of the star of David with a keg in the middle.)
(Jill watches the guy.)

JILL: That guy is a cocaine addict.

PAM: His nose is so big. I bet he just swishes it up. I hate those types.

JILL: He reminds me of Nannah a little.

PAM: Who?

JILL: Remember? She was the granddaughter of Willie Nelson.

PAM: Oh, I know Nannah. She was always so depressed. She always wore the same Joy Division sweater.

JILL: That's her.

PAM: I wonder what happened to her?

JILL: This is what I heard.

PAM: What?

JILL: It happened when you were out following the Grateful Dead around and doing your little acid trips.

PAM: Right.

JILL: Nannah, I guess, was upset or something. I heard rumors that her dad had been molesting her.

PAM: Yeah?

(A car drives by and a jockish-looking boy in a white baseball cap screams out his window, "Fuck hippies!")

JILL: I'm not exactly sure if it was her dad, it could've been her uncle, I'm not sure.

PAM: Right.

JILL: That's beside the point. She went through her father's coat pocket and found some gold coin that was supposedly worth a whole bunch of money.

PAM: Right.

JILL: And she took it to some pawnshop and got some cash for it. And went out and got a first class ticket to Paris, one-way.

PAM: Right.

JILL: When she got to Paris, I guess she must have been there only a few hours, and remember she wasn't a very experienced traveler, it was probably the only time she had been alone.

PAM: Right.

JILL: Well, she got murdered.

PAM: What?

JILL: Yep.

PAM: Oh my God.

JILL: Yep. They found her body in the river totally naked except for two mismatched socks. She had been raped and drowned in the river.

PAM: Christ.

JILL: When they did an autopsy on her body, you know they cut you open and stuff, right?

PAM: Right.

JILL: They found a little toad in her belly.

PAM: A toad?

JILL: It crawled in there while she was underwater.

PAM: Christ.

JILL: So anyway, they flew her body back home the next morning after they found her body. And at the funeral, Nannah's father was wearing his black suit.

PAM: Right.

JILL: And when he checked his inside pocket for his lucky coin it was gone.

PAM: Oh Lord.

(Jill flicks a crouton into a bush.)

(The Jewish boy with flyers kicks the soda machine and looks around to see if anyone is looking.)

JEWISH BOY: Does anyone have an extra dime!!!

5 items he became obsessed with

1. Gum
2. television
3. movie reference book
4. Sex Video starring Vanessa del Rio
5. Picture of his younger brother

S J PERELMAN

For 15 years the boy was obsessed with trying to forget his childhood. He would vacation for years at a time before returning home. He was usually pleased to get home until he actually got there. On about the second or third day he would get upset that thier were so many chickens in his yard.

His grandmother used to dress him up in pink outfits and take him to the zoo.

4 of my Favorite short story titles: THE BOY

1. Are You Decent, Memsahib
2. Walk the Plank Pussycat — You're on Camera
3. Hello, Central. Give me that Jolly old Pelf
4. Muddler on the Roof

As a child I was paddled in school. My mates often made fun of me because of my sloppy dress habits. I could only afford to eat Spam. Everyone in my family thought I would be a ditchdigger like my father.

Once more the scene is empty.

The boy had again paused in his reading aloud, but this time there must have been a period, perhaps even an indention, and he gave the impression that he was making an effort to indicate the end of a paragraph.

(The school boy straightened up to inspect the bark of the tree higher up.)

This scene should take place somewhere in Iceland.

Let's go to Inspiration Point. What do you think we should do up there? Anything but date rape.

"As previously stated, the two brothers were already there, so they might, if need be, protect themselves with this alibi—a suspect alibi in truth."

"...without allowing their mistrustful cousin...

Have many children:God loves children kids kill kids · · ·

Y^CA speech

the limbless boys had nothing to prove on the dance floor

FUCK HIS ASS

It was clear to me that I could no longer continue to live here on this island next to the naked boy. After falling off a cliff in Delaware, this was supposed to be my time to recoup, my time to regain what I had lost after I slipped and hit the rocky bottom and slimy sediment. So moved here, not for good, but for temporary. And there were moments when I felt I had found it, my heart started to catch its pace, my complexion began to clear and almost glisten, the bones in my body strengthened, and I felt as if the days passing were the days that the Lord intended me. It was dishonest, this way of thinking, it was all too easily erased, gone before I knew what peace had hit me. The little pecker attached to a lanky little smiling boy, who took to peeking in windows and pissing in my well and tossing pebbles at my chimney. His father, a clothed Anglo with no friends and a fiery temper, would just shoo me away whenever I tried to confront him. He would hush at me or growl or cough in my face with lips so chapped that they resembled cliffs themselves, cliffs of folded skin and cracked bloody reservoirs. He knew the woes of my fall, he found out from a letter that he had intercepted by bribing the postman with two dying hens and a gallon of homemade turtle soup. He had learned more than he should have. So he would always yell at me and scream that he was praying for me to fall again, this time fatally and all too untimely. He was extremely fond of this cruel taunt, but I shook it off because I knew there were no more mountains on this island, the mountains were all gone, shoveled away for houses to sit empty and depressed, amidst ugly stray dogs and manicured trees dug into the sand clots. I would watch his naked son play in the quicksand, tempting fate by letting himself dissolve up to the ankles and then quickly, like a monkey, grab a tree branch, jump up on the bark, and howl out loud like an idiot. At night before I slept I would think to myself about my accident, I would play it over in my mind, the crumbling

rocks and the final slippery step. I would always end the night's waking thoughts with a last-minute curse and a hostile crinkling of my mug, aimed in the direction of the naked boy. I felt in some odd and disturbing way that he was most likely watching me through a window and that I was getting back at him for it all.

DAVID BOWIE: I do believe in extraterrestrials, but it's not a significant part of my life.

ANON.: What's your favorite piece of art?

ICE T: My aquarium. I'll bet if you went into any Mafia boss's house, he'd have flowers and butterflies around.

ANON.: Butterflies?

ICE T: The guns are there, but even the Godfather died fucking around with his grandson in the rosebushes. After all the violence, you have to chill.

ANON.: How did you learn interior decorating?

ICE T: When I turned from gangster into player and started stealing. I had to get educated to what really was fly. If you're stealing, you steal a Sony, not a Gold Star.

ANON.: What are your favorite possessions?

ICE T: A pit bull named Felony and an English bulldog named Chopper.

JOHN CANDY: I am the type of guy who can take the fame and glory or leave it.

WIFE: I think you're a failure.

JOHN CANDY: I am. I'll be the first to take a bite of humble pie.

WIFE: Good.

JOHN CANDY: I was starring in films when I was just eight years old. I was just a boy.

WIFE: You weren't handsome.

JOHN CANDY: I'm still not handsome. I just survive on pure willpower. You know that.

WIFE: Our son has been traumatized by this whole thing. To me it's not as big a deal. Your being a failure is OK with me. It's just your self-loathing that I can't stand. Your constant pity, the way you always droop your head down and walk around depressed like that.

JOHN CANDY: Everything you just said is true. It's all there. To be honest with you I wish I would have been a carpenter like my father or I could have been a grave digger like my uncle.

WIFE: You should have been.

JOHN CANDY: At least then the pressure would be off.

CLINT EASTWOOD: I was never a sports fan.

ANON.: Even in high school?

CLINT EASTWOOD: In elementary school I played a little ball. I had a good curveball.

ANON.: Are you a big reader?

CLINT EASTWOOD: I like books about people. Crime novels.

ANON.: Jazz novels too?

CLINT EASTWOOD: Well I'd rather listen to jazz, not read about it. I read a book about Winston Churchill. He was scared of dying in his sleep. I'm that way too.

I. The War between Men and Women
US 1972 105m Technicolor Panavision
National General/Jalem/Llenroc/4D (Danny Arnold)

A half-blind cartoonist marries a divorcee and is
troubled by her ex-husband.

Semi-serious comedy vaguely based on Thurber, but
not so that you'd notice, apart from the blind hero;
generally neither funny nor affecting.

w Mel Shavelson, Danny Arnold, based on the
writings of James Thurber d Melville Shavelson
ph Charles F. Wheeler m Marvin Hamlisch
pd Stan Jolley

Jack Lemmon, Barbara Harris, Jason Robards Jnr.
Herb Edelman, Lisa Gerritsen

II. A lot of people have heard that name Satan. Not so many people know who he is. Satan is the god of the Self, called the God of the Self. He's the defeated foe. There really isn't any self, it's just a big bluff. So if you're a descendant of Adam—anybody here a descendant of Adam? Well, Adam got those keys (to Paradise) offa you, and Jesus Christ went to the cross to get those keys back.

Jarrod in a wheelchair sitting

~~clean~~

cleaning his apartment on PCP was always
fun for him. once He found an old copy
of Time magazine under his couch. THe
cover read "the secret world of Howard
Hughes!" when he opened it up he read
a passege the explained how ~~used~~ Hughes
used to take alchohol rub down bathes.
~~when He was done reading cleaning His~~
~~apartment was always an i~~ after he
was finished reading the article He called
up his oldest sister in wyoming. she told
Him that she was contemplating being
artificialy inseminiated.

154

a Father speaking to his son in a
Laundremat

~~so~~

Sometimes i feel like the elephant
man.

you should

why?

(Father begins drinking CLOROX straight from the container)
~~'cause you look exactly like him~~

averag man
5'8

Sons Favorite Foods
1. animal crackers
2. ~~fruit~~
3. sardines
4. titty milk

3. She once entered a beutiful-legs
contest and was beaten out by the
mike stand

155

IF YOUR MIND HAS BEEN HINDERED BY THE ENEMY

KID: What?

BASKETBALL COACH: Listen man, I ain't no kook, am I?

KID: No.

BASKETBALL COACH: So I'll tell you straight-up. No lies. You see, the Lord is hip, man. He's no joke.

KID: Yeah.

BASKETBALL COACH: Hell yeah. My wife, she came at me with all this, and I was like, I'm not gonna listen to this rubbish. But then it got me, and I found out the hard way. I had to lose before I could gain. You know what I'm trying to say don't you?

KID: Yeah.

BASKETBALL COACH: I had to fall flat down, smack down right on my head. But that's how he wakes things up. That's how he wakes the crickets up, you know what I'm trying to say?

(A few minutes later the basketball coach makes the boy strip down naked. The boy is shivering with his pale legs spread wide apart on the coach's gymnastic balance beam.)

BASKETBALL COACH: *(staring at the boy's private area.)* Your testicles have perfect symmetry.

(The boy blushes.)

EIGHT HOURS ARE NOT A DAY: CACOPHONOUS ANGEL

1. Rudolph Valentino was a short-order cook.

2. James Cagney met his wife while visiting the Borscht Belt.

3. She wanted so much to make Daddy proud of her. And he was proud of her. She was beautiful, athletic, easily adaptable, thrifty, and a good mother. Daddy was immaculately dressed in a top hat, white tie, and tails. He soft-shoed in and did a little fake tap dance to get her laughing.

4. He put a diamond bracelet beside her dinner plate and then pretended to be surprised when she found it.

5. Daddy danced with me on his knees. We were both so fond of harp music at the time.

STEADY KONNELY, WE ALL FEEL SORRY

(Close-up of a woman's chubby hand.
Her fingernails are bitten down to the quick.)

KONNELY: Oww!

(She is sitting on a small beige sofa. She is overweight and her hair
is brown and knotted. She is wearing navy blue gym shorts and a
yellow sleeveless T-shirt. One of her eyes is swollen and black.)

(There is an old woman in the background washing dishes.
The sound of water coming out of the faucet is heard.)

(There are two teenage boys sitting on opposite sides of her.
One of the boys is passed out with his head slumped over.
Konnely has her hand on his thigh.)

(She picks open the herpe on her lip and a steady stream
of blood drains down the side of her cheek.)

KONNELY: *(Calm.)* Blood on my chin.

(Two sisters are sitting next to each other on an orange corduroy
sofa.)

SISTER 1: You need a napkin?

KONNELY: Naw, it's cool.

(Konnely wipes the blood off with her finger
and then wipes her finger on the side of her sock.)

He was StruNg out... AN was all
goiN crazy oNe Night... and he
shot me iN the Foot... He tried
to kiLL me.

so How old were you?

I was 4

Lucifer

Pale rider
Jumps wHiter

Sick of the train
he galloped with a
FaLSE Pride to his
bitches side
— THE BASTARD wishet

i knew this guy who wanted to loose
a bunch of weight quickly so He
ate pounds and pounds of diet powder.
He ate so much diet powder that
he gained weight.

JOHN PAUL: Didn't you used to go to Hillsboro High?

JIMMY: Yeah.

JOHN PAUL: I know you.

JIMMY: Yeah.

JOHN PAUL: You look about twenty-eight years old.

TIM: In school when I was growing up there was this one kid who had no ears.

SALLY: That can't be.

TIM: It's true. He just had holes. These little holes on the sides of his head and he had very long hair that fell to his shoulders. The kids would walk up to him and blow the sides of his hair up so they could look at his holes.

SALLY: That is so mean.

TIM: I know. know. But at that age there doesn't have to be any motivation.

SALLY: But it's not really evil.

TIM: Have you ever gambled?

SALLY: I gambled on you. I gambled on my first husband.

TIM: And?

SALLY: I would just say that I got things from the relationship that I wouldn't have gotten if I had not met Clark.

TIM: You got a Baldwin piano with cherry-stained finger-prints on the ivory keys.

SALLY: I got a house and two kids.

TIM: The kids.

SALLY: I figure I won with the kids.

TIM: How do you figure?

SALLY: If Joey becomes a vet then he can support me when I'm older.

TIM: What about me?

SALLY: What about you?

TIM: If you and I are together still.

SALLY: We are a couple.

TIM: Then your son should not only support you when you

grow old but he should also take the initiative and take care of me.

SALLY: But you're the man.

TIM: If he takes care of me also then I won at gambling.

SALLY: How did you win?

TIM: I succeeded at seducing you. Marrying you, and in doing that, I am in some way connected to Joey. He must also pay for me when I'm too old. I won you, that way I won.

SALLY: I remember when I was in school. There was this one boy.

TIM: Did he have ears?

SALLY: Yes. He would stand by the soda machine near the cafeteria.

TIM: They had soda machines in the thirties?

SALLY: He looked a little like a warlock. If he had a cane he could've played the warlock in the school play.

TIM: Did you fancy him?

SALLY: Not really. He was too strange. Very dirty, and that was before dirty was in. And this guy would stand there in front of the soda machines and ask people for change.

TIM: Did you give him money?

SALLY: I never did. I was always kind of scared of him. He looked like a historical figure.

TIM: Did he look Russian?

SALLY: I guess.

TIM: Did he resemble Rasputin?

SALLY: If Rasputin had a brother this guy might pass. Except that his father was a milkman.

TIM: Don't milkmen get paid?

SALLY: In the beginning when he first started panhandling, the kids in school were surprised by what they were seeing.

TIM: What about teachers? In my school if that ever happened the teachers would take a shotgun and shoot him.

SALLY: The teachers were all scared. The school had no power against this guy. The principal bought a new soda machine and placed it at the other end of the hallway next to the gymnasium. But the guy still stood by the one machine even though everyone stopped going to the machine.

TIM: Did he graduate?

SALLY: I guess. My history teacher told me that he was a Mexican.

TO SEE A PONY TRAMP A PAIR (A SIGHT FOR SORE EYES)

LEONA UPTON: Both the girls, the twins, both Sarah and Nell, they were both stomped by a spooked pony. I saw Nell, she looks awful.

JOSEPH MOHR: How awful?

LEONA UPTON: Her appearance is so distraught that I can guarantee that no one will even recognize her.

JOSEPH MOHR: I feel so bad. I don't know what to do. I've known the twins since before they were baptized. I mean for God's sake I used to swim in their above-ground pool almost every day last summer.

LEONA UPTON: Well I love them too. But that damn pony just went wild. It's gonna get killed now. Judge Peterson put a death sentence on it.

JOSEPH MOHR: How does Sarah look?

LEONA UPTON: Sarah looks basically fine. One of her cheeks was trampled on, but the cheekbone wasn't smashed, just really, really badly bruised, like a bruised apple.

JOSEPH MOHR: That's the reason I ride mules. A mule can't buck worth a shit.

LETTER FROM TUPAC SHAKUR #2, TO A NINETEEN-YEAR-OLD GERMAN FAN, JULY 1992

Hey there Anna,

That picture of you was fly, Baby. Your eyes look blue but it's hard to tell. To be honest with you, you're the first German girl I've written, but the photo you sent me showed off those crazy-sized bosoms. My boy Philipo says them shits can't be real, but I defended your titties, Momma, them shits is no joke. I'd love to drink the milk out them shits. Real or fake, ain't no big thang, but the titties is boomin', Anna. I was sorry to hear that your little brother was arrested and locked up, but what the fuck's he doin' rapin' bitches? I heard Hitler liked to get shit on, so what's up?

Later,
Tupac

P.S.: Send more photos. I wanna whole roll of them titties to tack up on the tour bus, Baby. Also consider gettin' a nose job.

LETTER FROM TUPAC SHAKUR #3, TO HIS MOTHER, WRITTEN THREE WEEKS BEFORE HIS DEATH

Dear Mom,

I just got finished reading an article in the *New York Times* about a guy who got lost in the woods on a hiking trip. He survived by eating egg corns and wild berries. For some reason he was barefoot when he was rescued, in the picture of him his legs were all torn up and bruised. He looked so skinny but he was smiling in the picture. He was wandering around by himself for ten days straight. In the article he was quoted as saying, "I heard the sound of bagpipe music coming from the bottom of a mountain, I just closed my eyes and followed the music. When I finally reached the source of the music after walking for what seemed like hours. I opened my eyes and saw a deer having sex with a moose. I was so surprised to see two different species of animal engaged in sexual intercourse." In the photo the guy was wearing a Grateful Dead T-shirt, so I bet as you could imagine that he was on acid and that he was a hippie.

<div align="right">

Much love to you Moms,
Tupac

</div>

HE GATHERS HIS WISHES,
AND WHAT DISTURBS HIM

1. When he goes to the magazine store, the Arab men who work there have terrible body odor.

2. He was one of the 125,000 people in attendance at the Charlotte Speedway car show in July 1978 when a stuntman by the name of Bald Rey Rey Scartissue failed to jump the quarter-mile distance through six jutting streams of sky-high fire walls. Every time the car flipped, the announcer on the P.A. would yell out, "Over, over, over!" He would scream this out after every violent toss of the car. This man's voice haunted him.

3. His girlfriend put cocaine on the head of his pecker; he had a fear that the numbness would never go away.

4. Burt Lancaster's face.

5. ██████████████

6. His divorce at first seemed exciting. When his office burned in a fire he was sweeping up the mess by himself and felt a loss. In the old days, in a situation like this, his wife would have given him a special home perm or bought him Tylenol with codeine.

7. In an interview, Gary Coleman was quoted as saying, "I love doing voice-overs, because there's no three-dimensional representation, you can be as big as you want to be, as old as you want to be, or as young as you want to be. People don't have to judge [you]."

8. *The Washington Post.*

9. His brother was severely pigeon-toed. At the age of four, his brother was diagnosed extreme manic-depressive and took to sleeping nineteen hours a day.

10. Not seeing his children in the winter months.

11. He used to go to this one Spanish lobster restaurant that served two three-pound lobsters for $21.95. ███████████ ████████████ The restaurant switched owners and now the decor has changed to a more Middle Eastern feel. There are pictures of the Ayatollah Khomeini above the cash register. The waiters wear turbans and long beards and now the lobster special is called the Hummus Lobster Bomb Bisque. The price has also risen.

12. His preacher is a closet bigamist.

13. Mercury fillings.

14. Senior golf pros Lee Trevino, Jim Colbert, and Mario Lemieux.

15. Having to walk home from the horse races after losing a week's worth of earnings.

16. Anti-Zionists.

17. When he tore a girl's earring out of her ear (an attractive, partially deaf girl), it split the girl's lobe in half in the shape of an upside down letter *V.* He was very special friends with the sister of a well-respected plastic surgeon, and on certain occasions he would transport both her and her surgeon brother, and their gray spotted colt named Million Dollar Minnie, to several of the nation's most renowned rodeos and equestrian shows, mainly around the Southwestern parts of the United States. The plastic surgeon lied to the girl with the torn lower lobe and pretended that mending it was a very expensive operation ███████████████████████████ ██████████████████████████████ saying that the man who split her ear would pay every last operational cost. The plastic surgeon ended up charging his friend absolutely nothing for the swindling service (except for two tickets to see the Baltimore Orioles, who just happened to have been playing

badly because both the pitcher and the shortstop were out of the game, suffering from painfully shifting bone fragments).

19.

20. After the breakup with his wife, the women stopped coming around. Six days out of seven he wore a yellow T-shirt that read "Hugs not drugs."

All he would be was an observer. He waited with serenity. Life had never been good enough to him for him to wince at its destruction. He told himself that he was indifferent even to his own dissolution. It seemed to him that this indifference was the most that human dignity could achieve, and for the moment forgetting his lapses, forgetting even his narrow escape of the afternoon, he felt he had achieved it. To feel nothing was peace.

ABOUT THE AUTHOR

Harmony Korine is an internationally acclaimed filmmaker, writer, and artist who became the youngest credited screenwriter at age 19 for his sceenplay *Kids* (1995). His directorial debut, *Gummo* (1997), is one of the most controversial and influential films of independent cinema. He has written and directed the award winning films *Julien Donkey-Boy*, *Mister Lonely*, *Trash Humpers*, and *Spring Breakers*. His novel, *A Crack Up at the Race Riots*, was first published in 1998. He currently lives in Nashville, Tennessee with his wife Rachel and their daughter Lefty.